TREASURES FROM THE MINNEAPOLIS INSTITUTE OF ARTS

This book is dedicated with sincere appreciation to Robert J. Ulrich, chairman of the board of trustees of The Minneapolis Institute of Arts, in celebration of his generous and enduring support and leadership.

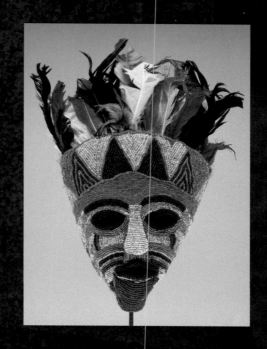

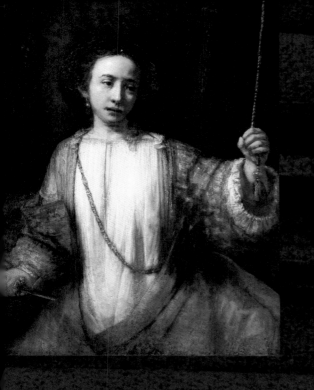

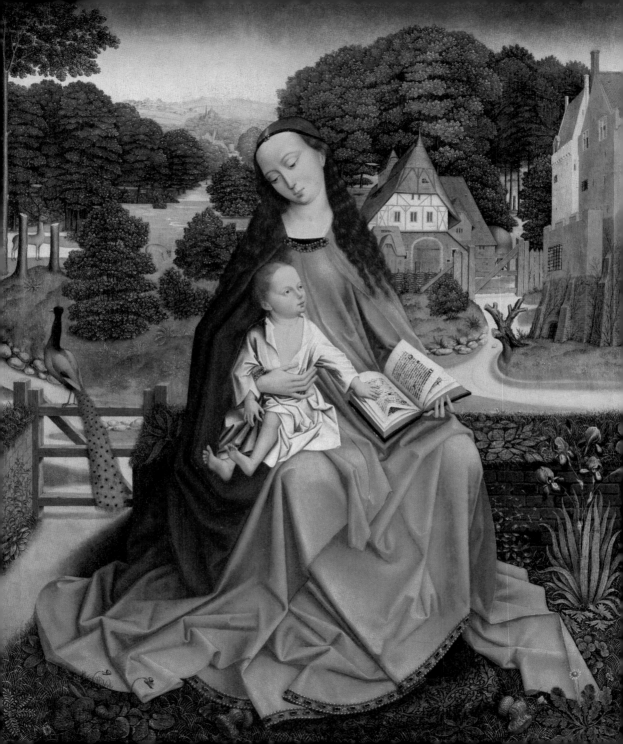

ACKNOWLEDGMENTS

Producing this volume was a cooperative endeavor, and I would like to acknowledge the many talented members of the Institute staff who contributed their time and expertise to the project. First, my thanks to my curatorial colleagues who chose the featured objects and prepared copy for their sections: Joe Horse Capture and Kyan Thornton, Africa, Oceania, and the Americas; Robert Jacobsen and Matthew Welch, Asian Art; Christopher Monkhouse, Catherine Futter, and Jennifer Komar Olivarez, Decorative Arts, Sculpture, and Architecture; Patrick Noon, Paintings; Carroll T. Hartwell and Christian Peterson, Photography; Richard Campbell, Dennis Michael Jon, Lisa Michaux, and Kristin Makholm, Prints and Drawings; and Lotus Stack, Textiles. I am also grateful to Carleen Pieper, Sandra Hoyt, and Sandra Lipshultz for their written and editorial contributions; to Gary Mortensen, Robert Fogt, and Alec Soth for their photographic expertise; and to Donald Leurquin, Publication Services Manager, for coordinating design and production with Larsen Design Office, Inc. of Minneapolis. Finally, I would like to thank John Easley, Director of Development and External Affairs, who conceived the project and saw it through to completion.

EVAN M. MAURER, DIRECTOR AND CEO
The Minneapolis Institute of Arts

MASTER OF THE EMBROIDERED FOLIAGE

FLEMISH, ACTIVE 1480–1500

Madonna and Child in a Landscape, about 1495–1500

Oil on panel

Gift of the Groves Foundation, by exchange

90.7

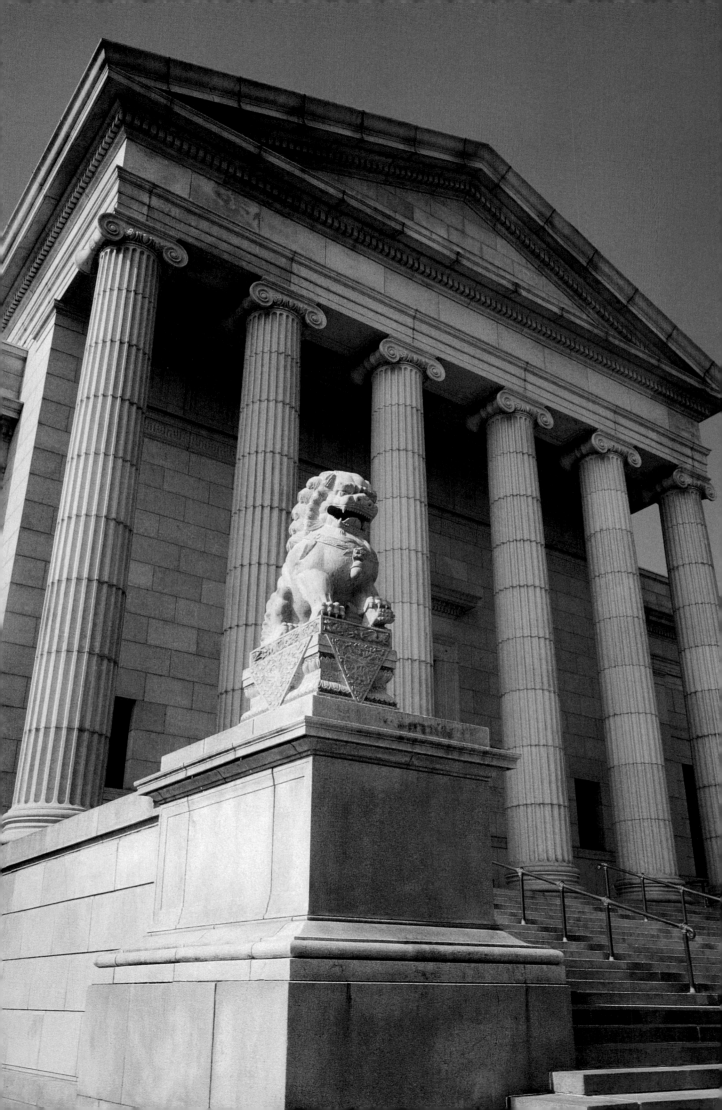

FOREWORD

In 1883, twenty-five citizens of Minneapolis joined together to found The Minneapolis Society of Fine Arts, committing themselves to bringing the arts into their community life. Now, more than a century later, the museum they created, The Minneapolis Institute of Arts, stands as a monument to this outstanding history of civic involvement and cultural achievement.

Much has changed since 1915, when the Institute first opened the doors of its classic building designed by McKim, Mead and White. Our collection has grown from about 800 pieces in 1915 to nearly 100,000 in 1998, including world-famous works that represent the highest levels of artistic achievement. These objects have been added to the collection thanks to the continuing generosity of donors who have either given works to the museum or provided funds and endowments specifically for the purchase of artworks. Without the support of these individuals, our collections would not exist.

Concurrent to the growth of our collection, our reach has expanded dramatically since the Institute's early days. Our membership has grown from some 300 members at the turn of the century to more than 26,000 households today. From their 1889 roots in a cramped top-floor classroom at the Minneapolis Public Library, our educational efforts have flourished to reach one out of every three schoolchildren in the state. And while annual attendance has increased to include hundreds of thousands of visitors, our admission fee has been eliminated, enabling us to share our cultural treasures with all audiences, regardless of economic means.

Equally striking have been the Institute's structural changes. From the elegant neoclassical core of the original building, the museum has grown to encompass eight indoor acres of inspirational and fully accessible space. In the past ten years, thanks to unprecedented community support, we have been able to dramatically expand our facility, increasing our gallery space by 65 percent and nearly quadrupling the number of works on display. These expansions allow us to exhibit our collections more fully than ever before. In addition, we have introduced a host of new public amenities to keep the Institute in step with changing audience needs, enabling us to help new generations of visitors enjoy art in fresh and innovative ways.

The growth and development of our museum would not have been possible without the extraordinary support of many generous and devoted patrons. Our success is directly related to the outstanding leadership of corporations, foundations, families, and individuals from the Minneapolis and St. Paul metropolitan area and from the state at large. Their steadfast belief in the importance of the museum's role in the community has allowed us to grow in new and exciting ways that have become national models for effective museum operation.

So as our collection of art treasures from around the world continues to grow and improve and our facilities continue to develop to accommodate new generations of visitors making connections with the great works of art we are privileged to share with our community, let us salute the fortitude of Minnesota's commitment to the arts. May that be the crowning glory of our museum for years to come.

EVAN M. MAURER, DIRECTOR AND CEO

The Minneapolis Institute of Arts

September 1998

HISTORICAL MILESTONES

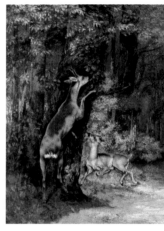

JANUARY 31, 1883—Fourteen men and eleven women sign articles of incorporation officially establishing The Minneapolis Society of Fine Arts, the city's first public arts institution. The group declares that the new organization's purpose is "to advance the knowledge and love of art." The Society selects University of Minnesota president William Watts Folwell as its first president.

[The American] educational system will be defective until it is crowned by the museum.

—William Watts Folwell, on his conviction that museums are a cornerstone of the public education system

1883—The Minneapolis Society of Fine Arts presents its first exhibition in the upper rooms of an unfinished commercial building, charging 25 cents a person to see an array of more than 250 paintings, 125 etchings and engravings, several sculptures, and other assorted bric-a-brac.

1889—The Society begins exhibiting art in a gallery in the new Minneapolis Public Library at Hennepin Avenue and Tenth Street. This one-room gallery serves as the Society's exhibition space until the construction of The Minneapolis Institute of Arts. This modest gallery displays the entire permanent collection of the Society—six paintings—as well as about one hundred paintings lent by various Minneapolis citizens.

FUN FACT: The permanent collection of The Minneapolis Institute of Arts grew from six paintings in 1889 to nearly 100,000 objects in 1998.

1900—The Society presents its first exhibition of American art in the public library gallery. The exhibition is praised as "the most important art event of the year" by the *Minneapolis Journal.*

1901—The Society completes its first membership campaign, expanding its ranks to 307 members.

FUN FACT: In 1998, The Minneapolis Institute of Arts has more than 26,000 members.

1908—Civic leader Clinton Morrison announces that he will donate his ten-acre family homestead, Villa Rosa, on the corner of Third Avenue South and East Twenty-fourth Street, as a site for a new art museum.

1 Catalogue from the 1883 "Art Loan" exhibition, the first art exhibition sponsored by The Minneapolis Society of Fine Arts

2 Early logo of The Minneapolis Society of Fine Arts

3 The Minneapolis Public Library building on Hennepin Avenue and Tenth Street, home of The Minneapolis Society of Fine Arts' single exhibition gallery from 1900 to 1915

4 Contract for the construction of the original McKim, Mead and White museum building, signed by The Minneapolis Society of Fine Arts and the J. & W. A. Elliott Co. on December 7, 1912

5 Gustave Courbet, *Deer in the Forest,* 1868, one of the first paintings contributed to the Institute's collection, given by James J. Hill in 1914

6 Clinton Morrison

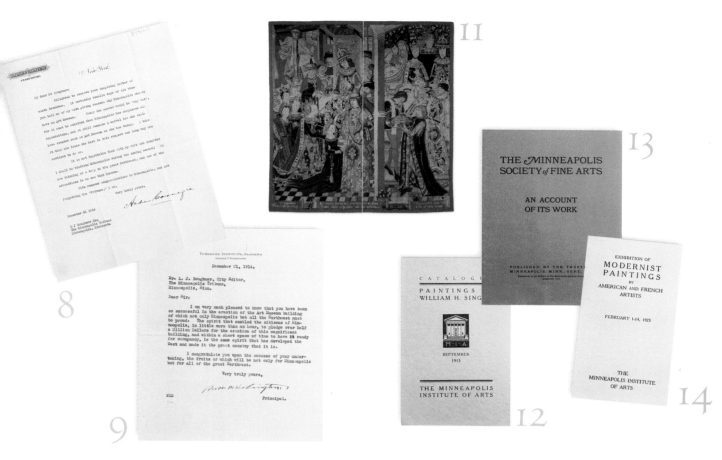

1921

1910—The Society begins raising funds and making plans to build a new museum on the Villa Rosa land. Milling executive William Hood Dunwoody launches the campaign with a gift of $100,000—the largest cash donation in the city's history at that time.

1911—McKim, Mead and White, the nation's most prestigious architectural firm, is chosen to design the new museum.

1914—Society president William Hood Dunwoody leaves $1 million in a trust fund designated for the acquisition of paintings.

The Institute will be a public museum of painting, sculpture, and the decorative arts, past and present, of all countries. Nothing is more instructive than to have in one museum the history of art from the remote past to the present day, noting how one period of art is developed from another, each new period being the result of all that has gone before.

—Joseph H. Breck, Institute director, on his vision that the Institute present an encyclopedic collection of art to the community, 1914

JANUARY 7, 1915—The Society celebrates the grand opening of The Minneapolis Institute of Arts.

Let me impress upon this institution not to spend money, that if husbanded would buy a good picture, on poor ones. Make your standard high and live to it. This Institute is to pitch the key. Do not pitch the key too low.

—James J. Hill, presenting a vision of excellence for the new museum in his remarks at the opening ceremony

Art is not just something attractive in a stone building where it can be visited and tea served now and then by "the better classes." The Art Institute is for the people to make the fullest use of and to protect from false friends, if they ever arise, who would monopolize it or make it "exclusive."

—Herschel V. Jones, editor of the *Minneapolis Journal,* following the opening of the new museum, 1915

FEBRUARY 1915—In its first month of operation, The Minneapolis Institute of Arts welcomes 80,000 visitors.

1921—The Ethel Morrison Van Derlip fund is established in memory of the wife of Minneapolis Society of Fine Arts president John R. Van Derlip. This fund, along with a later trust established by John R. Van Derlip, will eventually constitute the Institute's most important endowment for the acquisition of artwork.

7 William Hood Dunwoody

8 Personal letter from Andrew Carnegie offering congratulations on the opening of The Minneapolis Institute of Arts

9 Personal letter from Booker T. Washington congratulating Minneapolis on "the erection of the Art Museum building of which not only Minneapolis but all the Northwest must be proud"

10 Ethel Morrison Van Derlip

11 Flemish, *Esther and Ahasuerus,* about 1475–85, acquired in 1916

12 Catalogue from one of the Institute's first exhibitions, a selection of paintings by William H. Singer, in 1915

13 Pamphlet celebrating the achievements of The Minneapolis Society of Fine Arts and the opening of The Minneapolis Institute of Arts in 1915

14 Catalogue from a 1923 exhibition of modernist (Postimpressionist) paintings

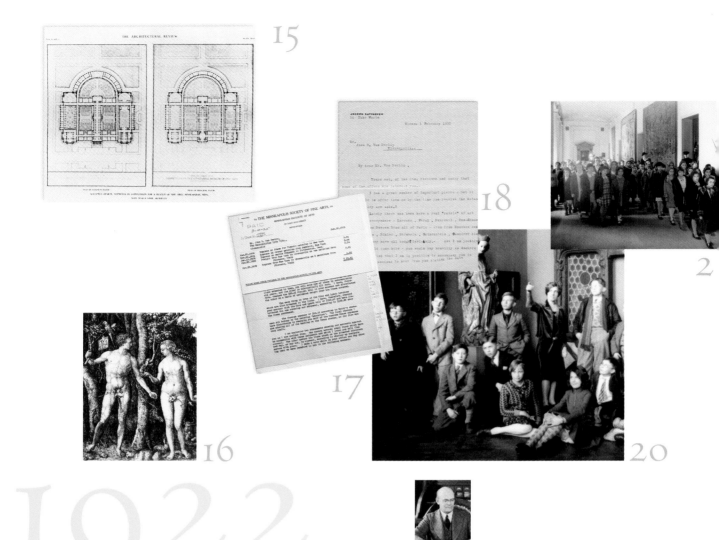

15

18

2

17

20

16

1922

19

1922—The Friends of the Institute is established.

1923—The Institute organizes an exhibition of Postimpressionist paintings that includes works by Matisse, Picasso, Braque, and Derain. Public outcry lambasts the exhibited works as "monstrosities."

The function of every museum…is to enable its public to be informed upon every art movement, whether attractive or unattractive, and it is for this reason only that this and similar exhibitions are displayed from time to time in the Institute of Arts.

—John R. Van Derlip, Minneapolis Society of Fine Arts president, explaining the reason for presenting the Postimpressionist paintings exhibition at the Institute, in spite of its controversial nature, 1923

1926—The Institute building expands to include a new south wing housing the Pillsbury Auditorium.

1942—Bruce B. Dayton becomes an Institute trustee, beginning more than fifty years of museum service as a patron, collector, and advisor.

1945—The Institute employs fifteen people.

FUN FACT: In 1998, the Institute has more than 200 regular employees and nearly 500 volunteers.

1948—Putnam Dana McMillan, Institute trustee, purchases André Derain's *St. Paul's from the Thames*, the first of many 19th- and early 20th-century masterpieces he would acquire and eventually bequeath to the Institute.

1950—Alfred Pillsbury, a prominent flour-milling executive and the Society's president

from 1935 to 1948, leaves his entire collection of Chinese art to the Institute. The *Minneapolis Journal* acknowledges the significance of this gift, citing Minneapolis "as one of the world's centers for the study of the arts of the East."

1974—The Institute celebrates the opening of two major new additions to the museum building, an adjoining building for the Children's Theatre Company, and a new building for the Minneapolis College of Art and Design. Senators Hubert Humphrey and Walter Mondale, Governor Wendell Anderson, and Minneapolis Mayor Albert J. Hofstede attend opening ceremonies celebrating the enlarged Institute facility and acknowledging the community's enduring support for the arts.

1983—The Minneapolis Society of Fine Arts celebrates its centennial.

15 McKim, Mead and White's first architectural plan for The Minneapolis Institute of Arts museum and arts complex

16 Albrecht Dürer, *Adam and Eve*, 1504, acquired in 1958

17 Invoice to John R. Van Derlip, one of the Institute's most generous early benefactors, for the purchase and shipment of six paintings and a marble fragment from a Florence, Italy, art dealer, 1925

18 Letter to Van Derlip from an art dealer describing works currently available for purchase

19 Alfred F. Pillsbury

20 Story hour at the Institute, 1928

21 Schoolchildren visiting the Institute, 1935

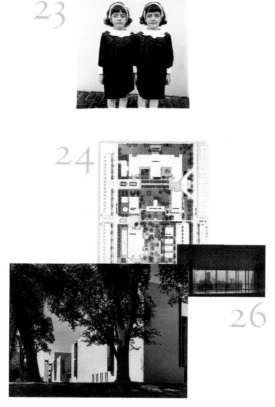

23

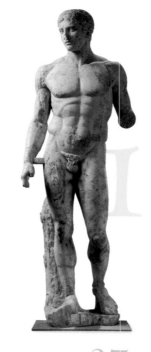

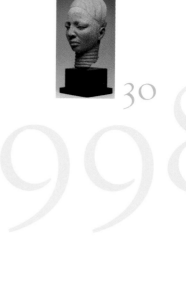

30

1998

24

26

27

25

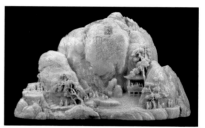

29

22

28

Art is forever young, and our goal must be to keep the Society, the College, and the Institute fresh and vibrant and relevant.

—Charles H. Bell, Institute trustee, expressing a vision for the next 100 years at The Minneapolis Society of Fine Arts' centennial birthday party, 1983

1988—The Minneapolis Society of Fine Arts reorganizes. The Minneapolis Institute of Arts and the Minneapolis College of Art and Design officially separate. The Minneapolis Institute of Arts makes plans for a comprehensive program of growth, renewal, and expansion.

1989—The Institute repeals its general admission fee, offering all visitors free access to its world-class collection of art. The Institute launches its "New Beginnings" campaign, chaired by Bruce B. Dayton and Burton D. Cohen, to raise $50 million for overall museum improvements.

We believe this new policy is evidence of our strong desire to make art more accessible to the general public and to eliminate barriers that might prevent full accessibility to our magnificent collection.

—Marvin Borman, chairman of the Institute's Board of Trustees, on the Institute's free admission policy, 1989

1992—The Institute opens the first of two building expansions and completes the first phase of gallery reinstallations and renovations.

1994—The Institute introduces a World Wide Web site, opening its doors to the world via computer.

1998—The Minneapolis Institute of Arts celebrates its grand re-opening, formally unveiling its newly expanded museum facility, saluting its 115-year history, and

embarking on a new century of visitor service and leadership in arts education.

It is through the arts of dance, music, song, poetry, literature, theater, and the many forms of visual arts—from personal adornment to ceramics, textiles, sculpture, drawing, painting, and architecture—that all human beings express the most important values of their lives, the values that tie them to the world of nature, to history, and to each other. Through the arts, humans express the sacred elements of their religion, their foundation myths, and their civic ethics. The arts express the most essential elements of humanity; therefore, through the arts we can better know ourselves and can better understand others of different backgrounds.

—Evan M. Maurer, Institute director and CEO, on the role of the arts in society, expressed in an inaugural address for Minneapolis Mayor Sharon Sayles Belton, 1998

22 James Ford Bell

23 Diane Arbus, *Identical Twins, Roselle, New Jersey*, 1966, acquired in 1972

24 Aerial view plan for the new arts complex (The Minneapolis Institute of Arts, the Children's Theatre, and the Minneapolis College of Art and Design)

25 The newly opened "Tange wing," 1975

26 The Minneapolis skyline, as viewed from the second floor of the Institute's new wing, 1974

27 Roman, after a 5th-century B.C. Greek original, *Doryphoros*, probably 1st century B.C. acquired in 1986

28 The Institute announces its "Open Doors" free admission policy with banners

29 Chinese, Ch'ing dynasty, *Jade Mountain*, 1784, acquired in 1992

30 Africa, Nigeria (Ife City), *Shrine Head*, 12th–14th century, acquired in 1995

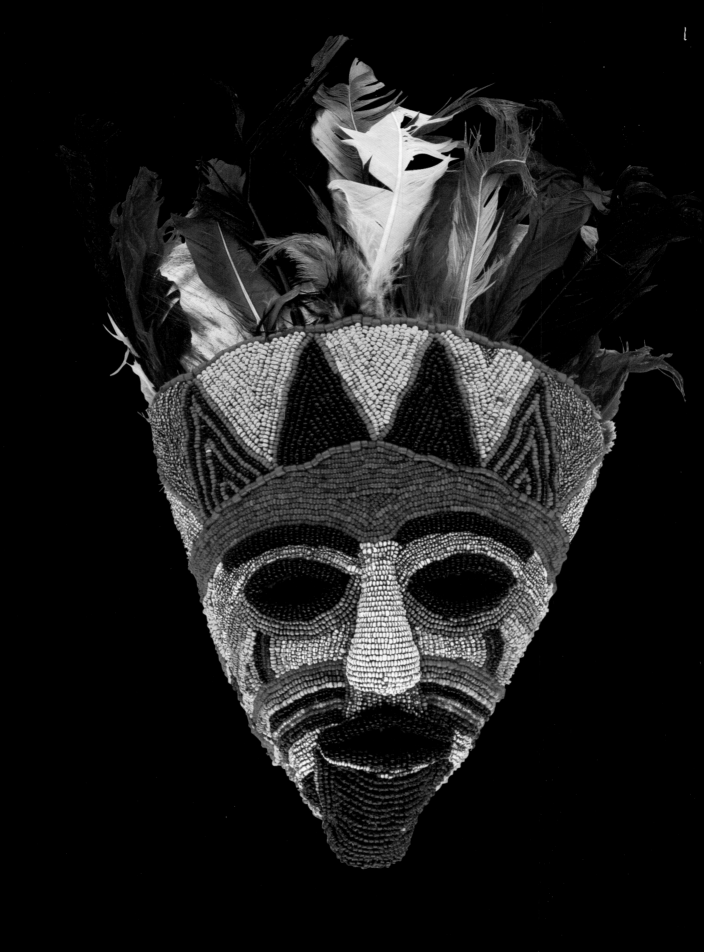

AFRICA OCEANIA AND THE AMERICAS COLLECTION

The Institute's collection of works of art from the broad geographical regions of Africa, Oceania, and the Americas has been greatly enlarged since its first ancient American ceramics were acquired in the early 1920s. Each area has its own particular strengths that, as a whole, present a fine overview of extraordinarily diverse creative traditions.

The arts of the huge territories of sub-Saharan Africa were first obtained by the Institute in the early 1950s, when such works as the 18th-century bronze leopard and carved ivory tusk from the Benin culture of Nigeria entered the collection. Since then, masterpieces from the early aesthetic traditions of Africa, such as the Nok figure (from around 450 B.C.) and the great Ife portrait head (about 1200–1400) have established the core of the collection. Metalwork and ceramics are well represented, as are the sculptural styles of the Congo region of central Africa.

Oceanic art represents the widely spread cultural groups of the Pacific Islands and Australia. We are especially fortunate to have three important sculptures from New Ireland, as well as a good selection of works from the many cultural traditions of New Guinea.

The arts of the indigenous native cultures of North, Central, and South America are especially distinguished by fine ceramics from ancient Western Mexico, the Mayan civilization, and the Moche and Nazca peoples of ancient Peru. The North American collections have a strong foundation in ancient ceramics of the Southeast and the Southwest, with fine historic period holdings of silver, basketry, and ceramics from the Southwestern Pueblo and Navajo traditions and a growing collection of outstanding Plains Indian painting, sculpture, and decorated clothing. All collection areas also contain works by contemporary artists who represent quality, continuity, and change in arts around the world.

Africa, Zambia (Tabwa)
Mask, 20th century
Glass beads, feathers, raffia, cloth, and skin
The William Hood Dunwoody Fund
89.14

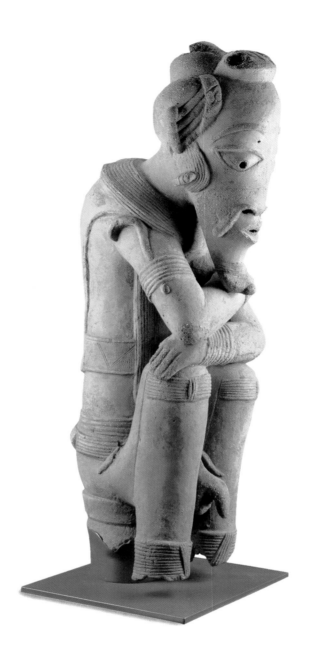

AFRICA, NIGERIA (NOK)

Seated Dignitary, about 500 B.C.

Terra-cotta

The John R. Van Derlip Fund

97.35

The Nok culture of northern Nigeria, a civilization that existed from about 500 B.C. to A.D. 500, is principally known for its terra-cotta figures. Relatively little has been discovered about the purpose of these extraordinary sculptures or the people who created them.

Characteristics that distinguish Nok sculptures from terra-cottas of later Nigerian cultures include the triangular pierced eyes, the elaborate coiffure and beard, and the placement of the ears. This work represents a person of high status. His elaborate beaded jewelry, dignified pose, baton, and hinged flail are symbols of authority that were also found in depictions of the Pharaohs and the god Osiris in ancient Egypt.

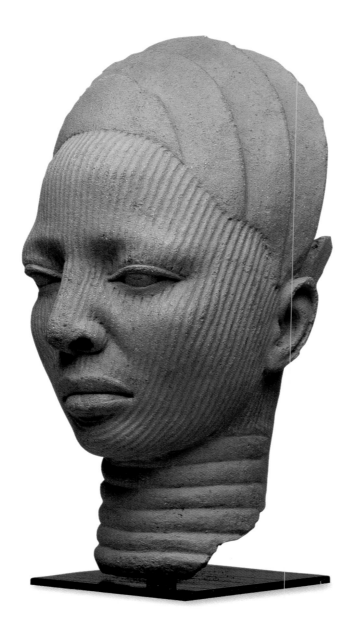

Between the 12th and 14th centuries, the royal city of Ife, in present-day Nigeria, was a center of economic, religious, and political power, and its importance was reflected in a highly developed and distinctive sculptural style. Portrait heads of terra-cotta or bronze stood on royal shrines in the palace compound. This head probably represents a woman of the royal court. The delicate lines on her face show a pattern of scarification, the cutting of designs into the skin to mark identity, status, and beauty. The realism of this portrait is unusual among African art styles, which typically present abstracted and generalized representations of the human image. Works of art from Ife are very rare. This superb creation is one of only three in American museum collections.

AFRICA, NIGERIA (IFE CITY)
Shrine Head, 12th–14th century
Terra-cotta
The John R. Van Derlip Fund
95.84

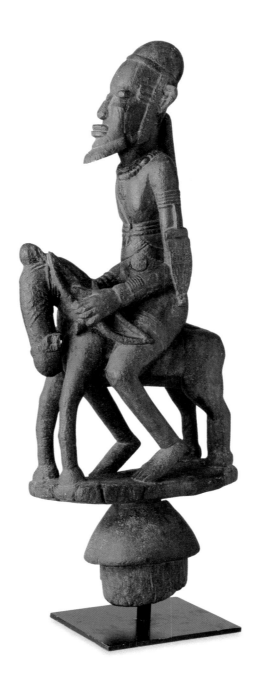

AFRICA, MALI (DJENNE)

Equestrian Figure, about A.D. 945–1245

Wood

The Centennial Fund

83.168

This extraordinary object is one of the two oldest known wooden sculptures from sub-Saharan Africa. Because of the region's climate, few early wooden artworks have survived. More commonly found bronzes and ceramics dating to the 5th century B.C. or earlier provide broad evidence of the age and sophistication of artistic traditions in Africa. This equestrian figure is stylistically close to the slightly later Djenne ceramic figures from the Niger River delta.

Equipped with a bow and quiver, the rider wears a small sheathed dagger on his arm. The sculptor has made him larger than the horse to emphasize his power and importance. As is true in many other world cultures, riding a horse signified high status and leadership.

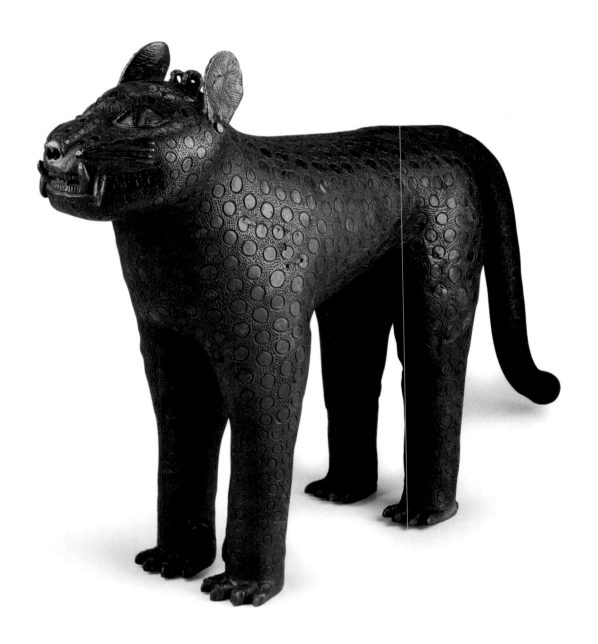

An aquamanile is an animal-shaped vessel used in royal hand washing ceremonies. Leopards are an important symbol of the Oba, a king who traces his ancestry back to Oba Ewuare the Great, who reigned in the mid-1400s. His special symbol was the leopard, and he is credited with the introduction of these bronze vessels, which are used only by the Oba in a ritual honoring his paternal ancestors.

AFRICA, NIGERIA (BENIN)
Leopard Aquamanile, 18th century
Bronze
Miscellaneous Works of Art Fund
58.9

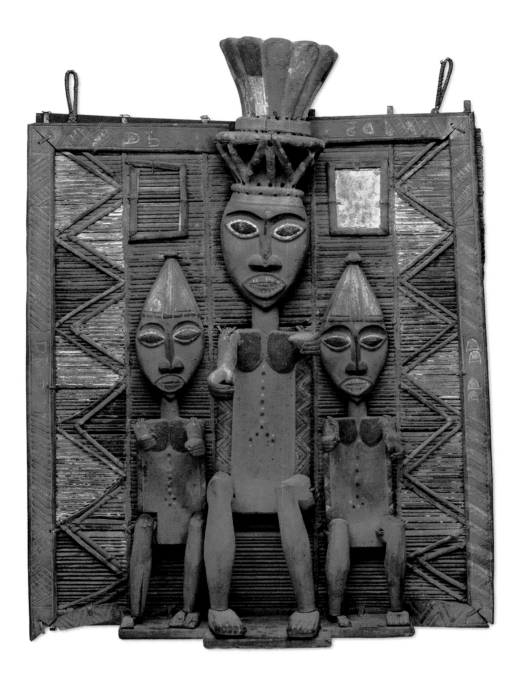

AFRICA, NIGERIA, ABONNEMA
VILLAGE (IJAW)
Duein Fobara
(Ekeine Society Memorial Screen),
late 19th century
Wood, raffia, and pigment
The John R. Van Derlip Fund
74.22

Ijaw people live on the coastal delta of the Niger River, a location advantageous to trade. When European merchants began voyages to Africa in the 15th century, the Ijaw served as middlemen in the exchange of gold, ivory, and slaves for European products. Certain families became extremely wealthy, comparable in their economic power to the merchant princes of Europe.

When a member of a trading house died, relatives commissioned an artist to produce a memorial screen called a *duein fobara*, or forehead of the dead. For Ijaw people, one's immortal spirit resides in the forehead, and the screen becomes the spirit's home after death. The deceased is represented at the center, surrounded by servants. The screen is kept in the trading house and given symbolic offerings of food and drink. Although trading houses have declined in power and importance, *duein fobara* screens are still occasionally made.

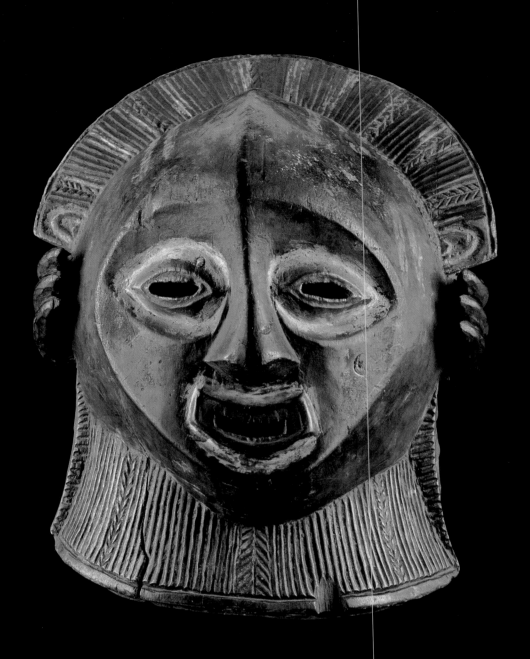

Large dance masks like this one were used by Kasai Luba people, an isolated group of Luba speakers who migrated west of their homeland in the 18th century. Masks were not widely used in the center of the Luba empire, but people in remote areas borrowed and adapted the masquerades of their neighbors. On this example, the hair and beard are elaborately braided and the teeth are decoratively filed. This is one of only two examples of this type of helmet mask in museum collections.

AFRICA, DEMOCRATIC REPUBLIC
OF CONGO (LUBA)
Dance Mask, 19th century
Wood and pigments
Gift of Stephen, Peter,
and Michael Pflaum in memory
of their grandfather,
Arther G. Cohen
53.14

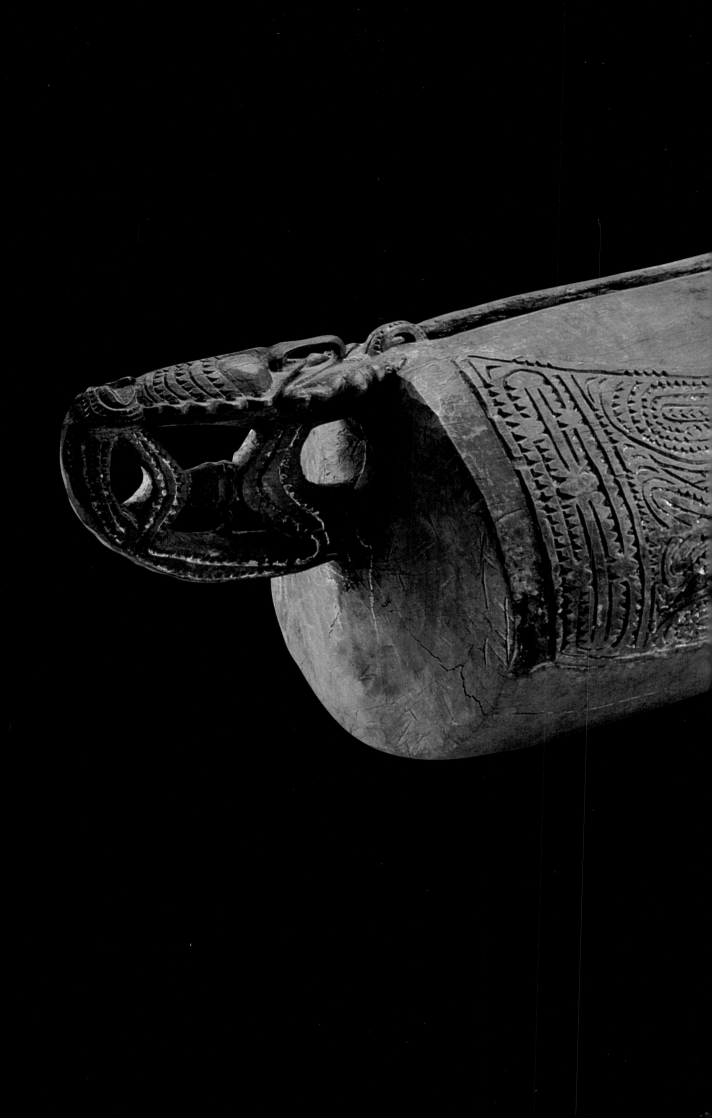

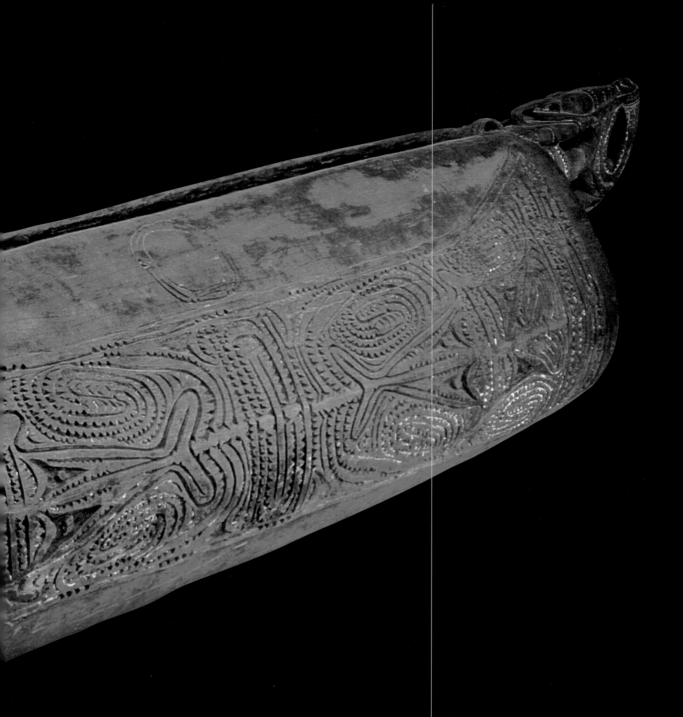

The *garamut*, or slit drum, is one of the most important musical instruments in the Sepik River region. It is used in communal ceremonies and dances and as a mode of communication. Drummers have created a special language of rhythms to call meetings, issue warnings, and send other messages. The long, beaklike noses and elaborately decorated coiffures on the anthropomorphic handles of this drum illustrate the unique artistic style of the Sepik River area.

PAPUA NEW GUINEA,
SEPIK RIVER REGION
Slit Drum, 20th century
Wood
The Christina N. and Swan J. Turnblad
Memorial Fund
93.12

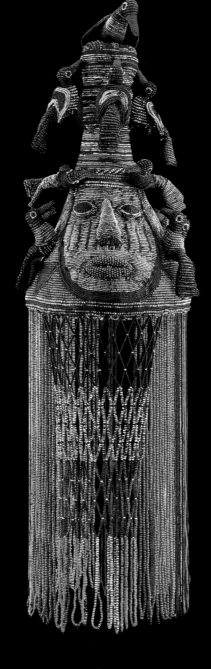

ıca, Nigeria (Yoruba)

ed Crown, about 1920

s beads, leather, canvas, and wicker

Ethel Morrison Van Derlip Fund

9

Among the Yoruba of western Nigeria, the use of beaded accessories was restricted to kings, priests and priestesses, and herbalist-diviners. Only kings, however, could enjoy the full range of beaded regalia: slippers, fans, fly whisks, footrests, canes, staffs, thrones, and crowns. Among the most important elements of an Oba's official ceremonial dress are tall, conical beaded crowns (*adenla*). The face on the front may represent gods or royal ancestors. The birds are *okin*, the royal bird, and also refer to the power of women in royal authority. The veil of beads shields ordinary people from the power of the king and subordinates his identity to the continuity of the ruling dynasty.

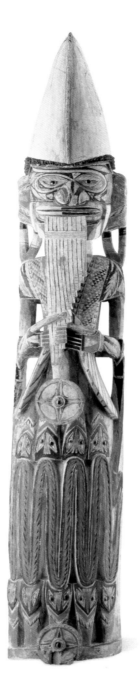

This standing figure represents a clan ancestor or recently deceased person who was being honored in a malagan memorial ceremony, a significant observance in New Ireland religious and social life. Malagan ceremonies were held to commemorate an important person's death, initiate young men and women, and settle legal disputes. Traditionally, large figures such as this were made for a specific malagan and later discarded. This is one of the only large figures of its type in existence.

NEW IRELAND,
PAPUA NEW GUINEA
Standing Figure with Pan Pipes,
19th century
Wood, pigments, and opercula
Gift of Myron Kunin
85.93

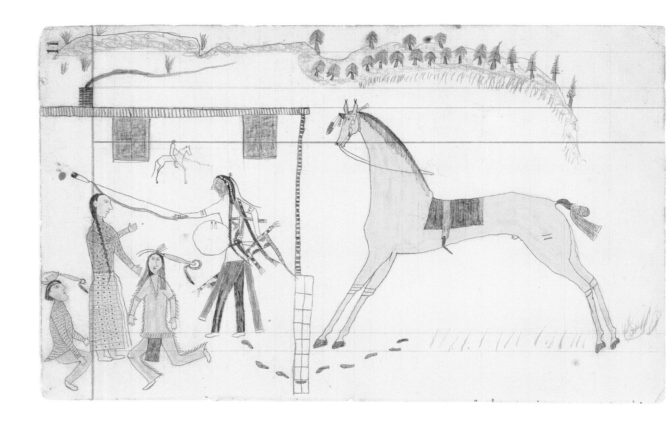

ATTRIBUTED TO BIG CLOUD

TSISTSISTAS (CHEYENNE),

ACTIVE LATE 1800S

Counting Coup, about 1880

Graphite and colored pencil on paper

Gift of Jud and Lisa Dayton

89.41

When buffalo and other large game animals became scarce, Plains Indian warrior-artists transferred their drawing skills from animal hides to paper. In sketchbooks or ledger books, they continued to depict their battle exploits but also began to record domestic scenes. In this drawing, the artist portrays a warrior counting coup, or touching the enemy in battle, the highest form of honor in Plains warfare. The warrior dismounts, follows the footprints into the house, and counts coup, first on the two men, shown by the horse quirt on top of their heads, and then on the woman with his bow.

Big Cloud has taken full advantage of this medium, using colored pencils to provide important details about the landscape, personal adornments, and particular elements of the enemy's clothing.

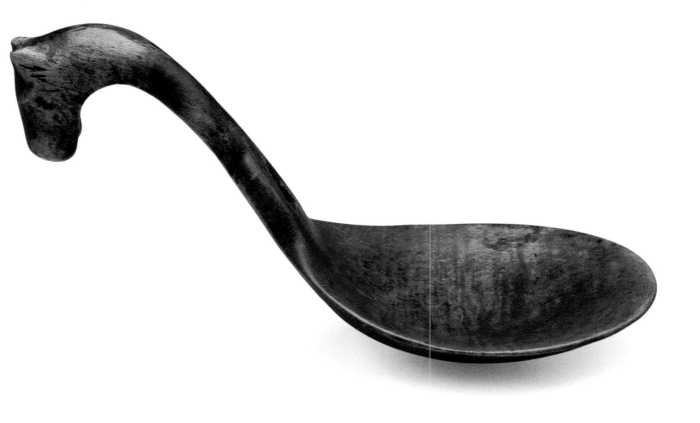

Carved wooden ladles used for ceremonial feasts are among the finest examples of Mesquakie sculpture. The handle of this ladle is decorated with a horse effigy representing a clan or society affiliation. During the 19th century, the Mesquakie relied on horses for hunting and travel over the open prairies, which is why horse images are common in many forms of Mesquakie artwork.

North America, Great Lakes region (Mesquakie)
Ladle with Horse's Head,
19th century
Wood
The Ethel Morrison Van Derlip Fund
96.114

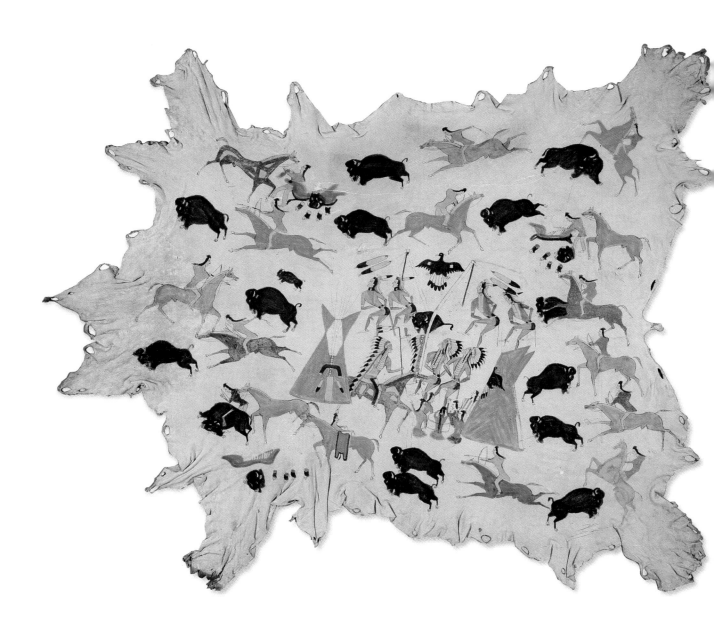

ATTRIBUTED TO CADZI CODY
WIND RIVER SHOSHONE,
1866–1912
GREAT PLAINS REGION, WYOMING
Scenes of Plains Indian Life, about 1900
Elkhide with pigment
Gift of Bruce B. Dayton
85.92

For centuries, Plains men recorded stories and events through hide paintings. Like his contemporaries, Cadzi Cody pictured things he remembered before his people were confined to the reservation. The Sun Dance, represented by the forked tree in the center of the hide, is the most sacred of all Plains ceremonies. It is held annually, and participants fast and pray for several days, offering themselves to the creator. The buffalo head between the forks honors the spirit of the animal, an integral aspect of Plains life. The male dancers dressed in eagle feather bustles, war bonnets, and bells are doing the Grass Dance, a predecessor of today's powwows that is a special time for celebrating and socializing. Cadzi Cody included a traditional buffalo hunt scene to make the painting more salable to white tourists who visited the reservation to observe the Sun Dance.

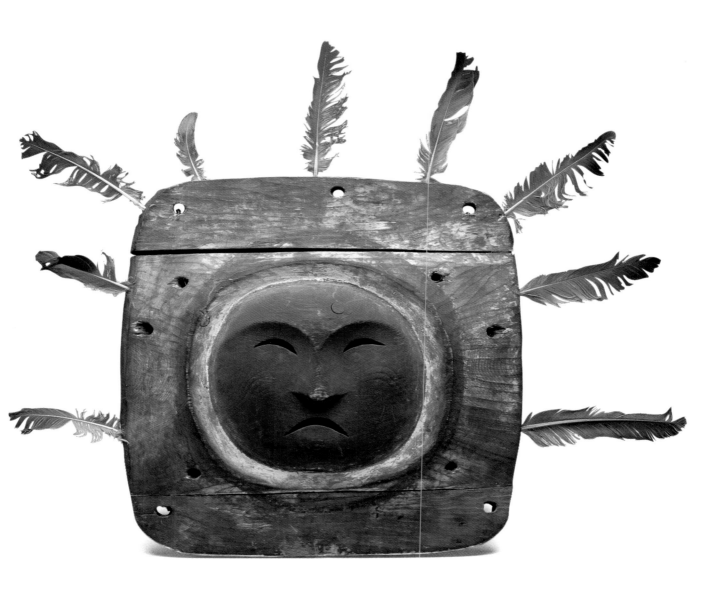

Inuit (Eskimo) people have long maintained an annual cycle of ceremonies and festivals, passing Arctic nights in storytelling, singing, and dramatic masked performances. These events focused on overcoming the harsh climate through practical means—enlisting spiritual aid for successful hunting, for example. In doing so, they promoted the social bonds necessary for survival in a challenging natural environment. Shamans organized ceremonial dances and the carving of dance masks, which were made by men. Artists had just a few materials, like driftwood, bone, fur, and feathers, but they used them to advantage, developing the spare, expressive style seen in this work. The delicately carved features of this mask probably represent a woman.

North America, Nunivak Island, Alaska (Inuit)
Mask, 19th–early 20th century
Wood and feathers
The John R. Van Derlip Fund
81.14

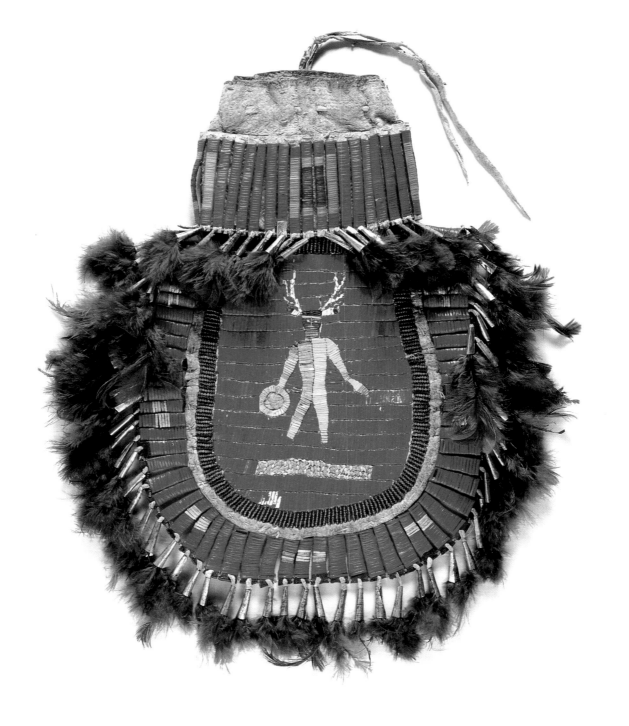

GREAT PLAINS REGION,
UNITED STATES (LAKOTA)
Elk Dreamer's Society Pouch, 1890–1910
Porcupine quills, hide, beads,
tin, and feathers
The Ethel Morrison Van Derlip Fund
96.115

For centuries, the Plains and Woodlands peoples have been decorating objects and clothing with porcupine quills. Because the appliqué technique is so laborious, one object can take months to complete. When European traders introduced glass beads, many quillworkers switched to beading because it is less labor intensive. Beads are also colorfast and more durable.

The figure on this small bag represents a member of the Elk Dreamer's Society. Men or women who dreamt of elk could be accepted into the society because they had acquired special powers, including the ability to influence matters of love. Elk are very social animals, and the bulls are protective of their mates and aggressive toward challengers during mating season; this behavior is associated with sexual prowess.

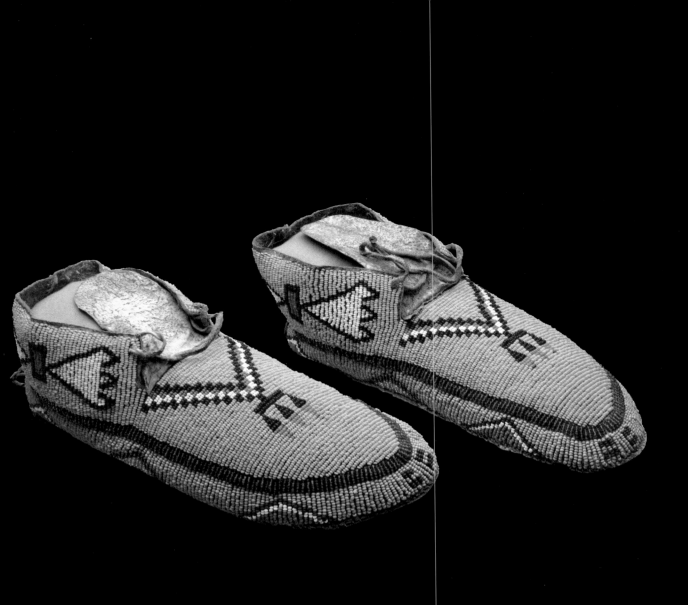

Moccasins can often be attributed to a specific tribe by their construction, surface ornamentation, and color. Most of the designs are geometric and refer to important elements of tribal life. The two-toned elongated diamond shapes on this pair are commonly interpreted as feathers. Decoration of these moccasins is based on two tribal styles, the A'ani (Gros Ventre) and the Nakoda (Assiniboine). Both of these tribes were placed on Fort Belknap Indian Reservation in central Montana in 1888. As they began to interact, artistic styles merged into what is known as the Fort Belknap style.

GREAT PLAINS REGION,
UNITED STATES
A'ANI (GROS VENTRE)/NAKODA
(ASSINIBOINE)
Moccasins, about 1890
Leather and beads
The Walter R. Bollinger Fund
98.10a,b

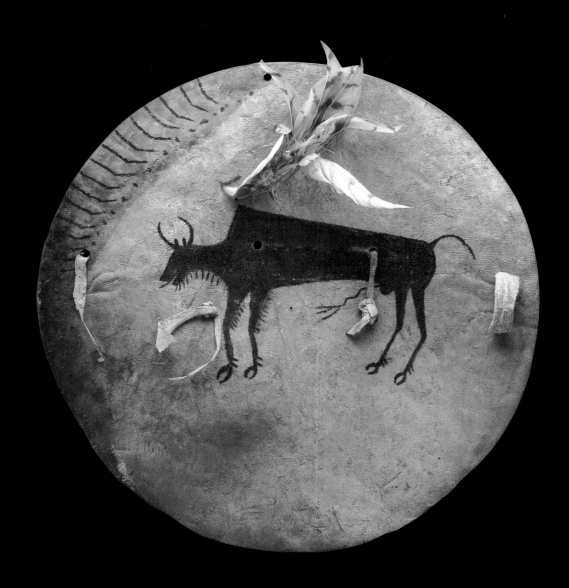

FULL-MOUTH-BUFFALO
(HUMPED WOLF)
APSAALOOKA (CROW)
Shield, about 1870
Hide, feathers, and pigment
The Christina N. and Swan J. Turnblad
Memorial Fund and gift
of the Curtis Galleries
87.51

For generations of Plains Indian warriors, shields were an important form of physical and spiritual protection. Considered sacred by all tribes, shields got their spiritual power from an image that came to the owner through a visionary experience.

As a young man, Humped Wolf was wounded in the leg in a battle with the Lakota. When snow began falling, he sought refuge inside a buffalo carcass. There he had a vision of a buffalo-man giving him this shield design and telling him to change his name to Full-Mouth-Buffalo. According to oral tradition, the buffalo in the center represents the buffalo-man from his vision. The green part of the shield represents spring and summer, the traditional seasons of battle. The black dots signify bullets, and the bent lines show their path as they are deflected by the power of the shield.

Between 200 B.C. and A.D. 300, a highly developed culture existed on the Pacific coast of Mexico, in the present-day states of Nayarit, Colima, and Jalisco. Our

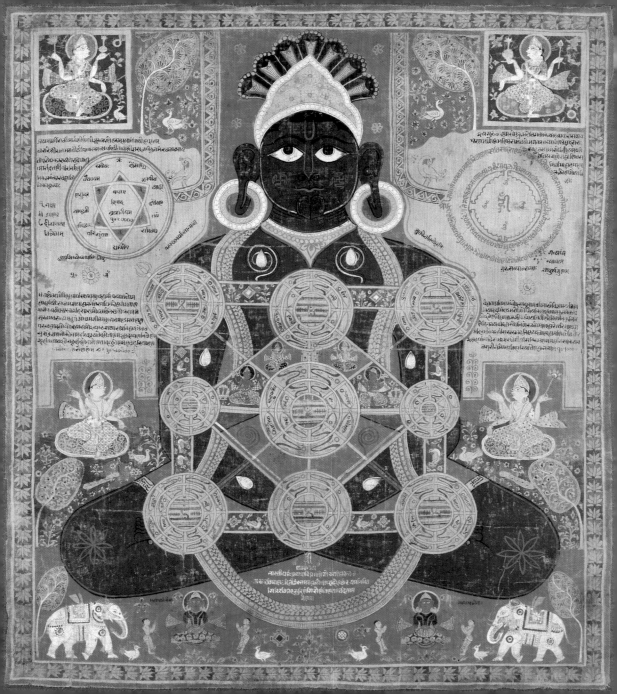

ASIAN ART COLLECTION

The Institute's collection of Asian art represents seventeen Asian cultures spanning nearly 5,000 years. The Department of Asian Art has benefited greatly from generous gifts from serious and knowledgeable collectors. Augustus L. Searle, Alfred F. Pillsbury, Richard P. Gale, Louis W. Hill, Jr., and Ruth and Bruce Dayton have donated specialized collections of international reputation, including ancient Chinese bronzes, ancient and post-Sung jade, Chinese monochrome ceramics, Ukiyo-e paintings, Japanese prints, and most recently, classical Chinese furniture. In addition, highly regarded specialized collections of Ch'ing dynasty silk textiles, Miao textiles, and surimono prints have been built over the years.

The Institute established a curatorial department for Asian art in 1977. Throughout the 1980s and early 1990s, the collecting goal has been to add significant objects in areas of greatest weakness to provide the public as broad an overview of Asian art as possible. This has been achieved through purchase endowments and the continued support of private donors.

With the summer 1998 opening of the new galleries of Asian art, the museum presented the Indian, Islamic, Himalayan, Southeast Asian, and Korean permanent collections for the first time. In addition, the Chinese and Japanese holdings, which contain the largest percentage of the more than 6,500 Asian objects owned by the museum, are now displayed in twenty-two new galleries.

An important focus for the future will be classical Chinese and Japanese architecture. An original reception hall from the late Ming dynasty and an 18th-century Suchou-area library will become the centerpiece galleries for the renowned collections of 17th- and 18th-century Chinese furniture, literati objects, and paintings that have been acquired recently through the extraordinary generosity of Ruth and Bruce Dayton. While building these focused collections, the Daytons have strategically added important gifts of sculpture, ceramics, bronzes, gold, calligraphy, and Nanga painting to our holdings. Along with other dedicated patrons, they have contributed significantly to the accelerated growth of the museum's Asian collections over the past decade.

INDIAN, RAJASTHAN REGION

Cosmic Parsvanatha, about 1525

Colors on cotton

The Katherine Kittredge McMillan

Memorial Fund

97.77

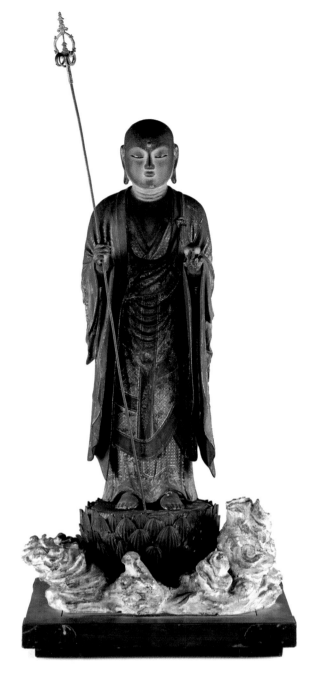

JAPANESE

Jizō, early 13th century

Wood, lacquer, colors, and gilt

Gift of Anne de Uribe Echebarria

in honor of her husband,

Luis de Uribe Echebarria;

Mary Livingston Griggs;

the Mary Griggs Burke Foundation;

Mary Griggs Burke; the

Putnam Dana McMillan Fund; and the

William Hood Dunwoody Fund

86.7

Jizō is a *bodhisattva*, a divine being of infinite grace and compassion who forestalls his own Buddhahood in order to help sentient beings to enlightenment. Since the 10th century, he has been portrayed as a young itinerant monk who carries a pilgrim's staff and a wish-granting jewel. He is popularly believed to assist those condemned to the torments of hell, as well as the wayward souls of deceased children. This statue shows Jizō descending from the heavens, as suggested by the cloud supporting his lotus pedestal. The exquisite workmanship and elegance of the figure, particularly the serene beauty of the face, are elements associated with the Kei school of sculptors active during the Kamakura period (1185–1336).

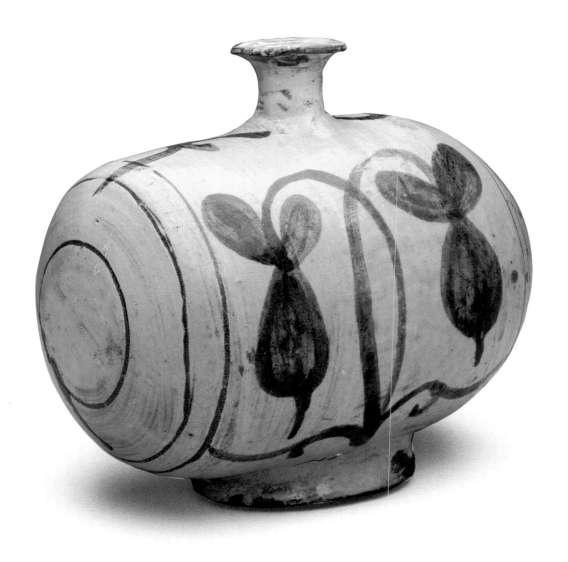

Punch'ong ware was the dominant ceramic produced during the early Choson period (1392–1910) in Korea. Coarse and unassuming, punch'ong was used by all levels of society, even the royal court, in a pointed rejection of the opulence and excess associated with the previous Koryo dynasty, when inlaid celadon was popular. This horizontal bottle represents a type of painted punch'ong produced at the kilns of Mount Keryong, in south central Korea. When the early rulers of the Yi dynasty rejected Buddhism in favor of Confucianism, many monks were forced to return to secular life. The former monks of Keryong set up kilns and began to produce punch'ong with designs in iron oxide over a rapidly applied white slip. Admired for its earthy feel and the spontaneity of its designs, punch'ong ware also became a favorite among Japanese tea masters.

KOREAN

Rice Bale Bottle, 15th century

Punch'ong ware; glazed stoneware

with painted slip decoration

Gift of funds from

Fred and Ellen Wells

97.121.2

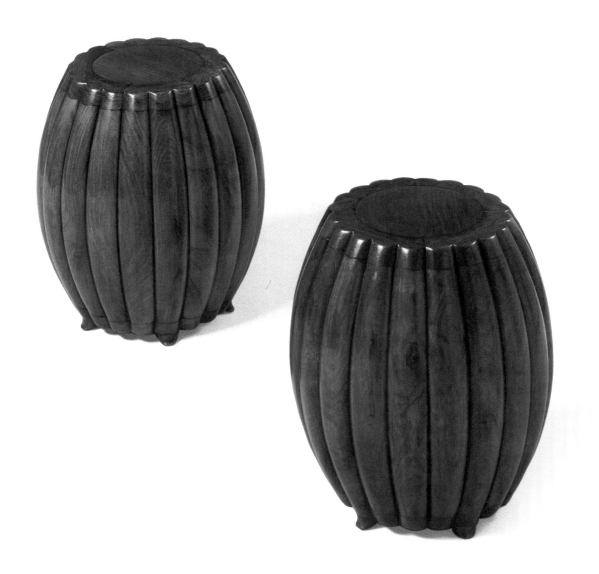

Chinese,

Ch'ing dynasty

Pair of Melon-Shaped Stools,

late 17th century

Huang-hua-li hardwood

Gift of Ruth and Bruce Dayton

97.89.1,2

Though they were popular throughout the Ming and Ch'ing dynasties, relatively few round *huang-hua-li* stools have survived. Crafted from well-figured hardwood, this exceptionally refined pair is based on a melon form. Each stool is constructed with twenty curved uprights which mortise and tenon into the mitered frames of the top and base. With no exposed tenons to disrupt the surface continuity, the joinery appears nearly seamless. The small, outwardly turned feet lend a sense of lightness and elegance to the taut form.

High yoke-back armchairs were reserved for the eldest and most important members of a traditional Chinese household. Stools and benches were typically used by younger people, women, and servants. Round stools made from a variety of materials, including stone, bamboo, and porcelain, were often used in garden settings.

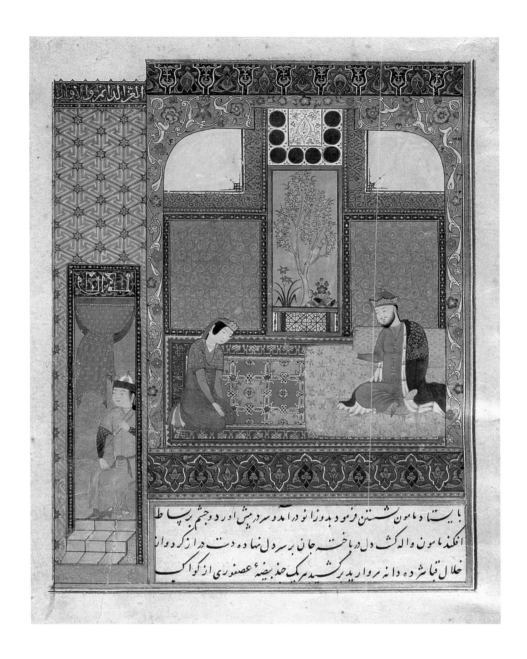

The Persian art patron Shah Rukh was partial to historical subjects and natural color. His son Baysanghur preferred small paintings in primary colors made from the finest ground metallic-oxide pigments, accompanied by stylish calligraphy. This work, with its small-scale figures, exquisite colors, and exacting draftsmanship, is typical of Timurid-period paintings and represents the Baysanghur style at its best. The leaf is from the *Chahar Magaleh* (Four Discourses), also known as *The Mirror for Princes*. In a series of anecdotes, this 12th-century text describes the four advisors an Islamic prince required—a scribe, a poet, an astrologer, and a physician.

IRANIAN,

TIMURID DYNASTY,

HERAT SCHOOL

A King and a Queen in a Garden, 1431

Ink, colors, and gold on paper

Bequest of Mrs. Margaret McMillan

Webber in memory of her mother,

Katherine Kittredge McMillan

51.37.30

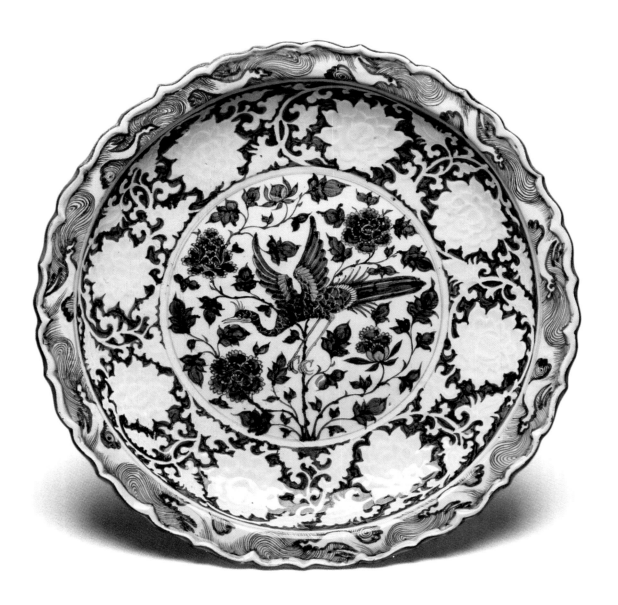

CHINESE, YUAN DYNASTY
Plate, early 14th century
Ching-te-chen ware; porcelain
with molded and underglaze blue decor
The John R. Van Derlip Fund and
gift of the Director's Tour
87.62

Underglaze decorated blue and white is considered the quintessential Chinese ceramic. Muslim merchants living in southern Chinese cities created the earliest demand for such works, commissioning pieces and shipping them to markets in the Middle East under the encouragement of the Mongol government. This plate's large scale, foliate rim, and densely painted decor indicate that it was created for the Middle Eastern market.

Such works represented the most advanced ceramic technology in the world. They also revealed a change in the Chinese aesthetic, from an emphasis on shape and glaze to painted pictorial surface. Some of the finest Yuan dynasty blue and white collections remain in Iran, Turkey, and Iraq, where they were first purchased by wealthy sultans in the 14th century.

Japan's peaceful pre-modern era, artists enjoyed the patronage of an increas-
wealthy urban population. Those of the Maruyama school combined Western
with the indigenous penchant for decorative design to produce works of
naturalism and pleasing visual effect. Nagasawa Roshū, pupil of the progeni-
the school and adopted son of one of its leaders, was himself a master of
le. *Birds and Flowering Plants* is a large and impressive example of his work and
which he cleverly pays homage to the eccentric compositions of his adoptive

NAGASAWA ROSHŪ
JAPANESE, 1767–1847
Birds and Flowering Plants, about 18..
Pair of hanging scrolls; ink
and colors on silk
The Ethel Morrison Van Derlip
and gift of Mary Burke,

Tall and magnificent, twelve-panel screens became fashionable during the Kang-hsi reign (1661–1722). Each of the hinged panels framed a painting or calligraphy. This may be the only *huang-hua-li* screen to have retained its original paintings. The panoramic scene depicts a son's capping ceremony at an aristocratic villa. The open carving is finely finished on both sides, a rarity on large screens. The upper and lower wood panels display hornless dragons surrounding a medallion with stylized *shou* (longevity) characters. Large screens like this served as backdrops to chairs and couches of important individuals and as backgrounds to altar tables.

CHINESE,
EARLY CH'ING DYNASTY
Twelve-Panel Folding Screen,
late 17th century
Huang-hua-li hardwood and
ink and colors on silk
Gift of Ruth and Bruce Dayton
96.124.1.1–12

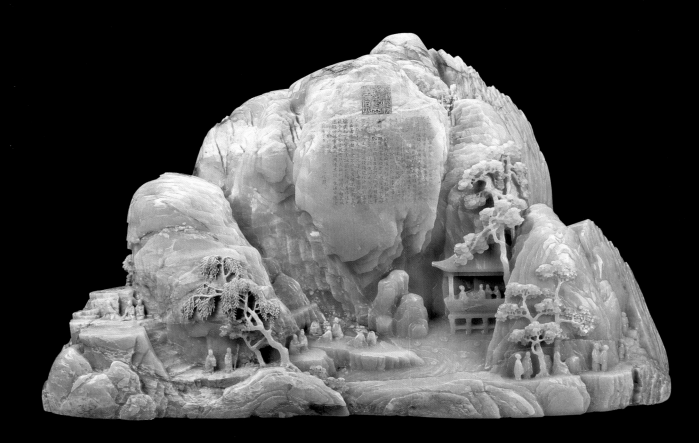

This mountain, apparently the largest piece of historic carved jade outside of China, was commissioned in 1784 by the Ch'ien-lung emperor (1736–95), whose own poem is carved on the backside. The front displays a longer verse, the *Lan T'ing Su* (Prelude to the Orchid Pavilion), a famous poem composed in 353 by Wang Hsi-chi, perhaps the greatest calligrapher of the Far East. The occasion for the poem is illustrated by this jade carving, a literary gathering of poets and scholars organized by Wang at Lan T'ing, the Orchard Pavilion. Several literati can be seen writing, drinking wine, and collating texts near the Orchard Pavilion at the foot of Mount Hui-chi.

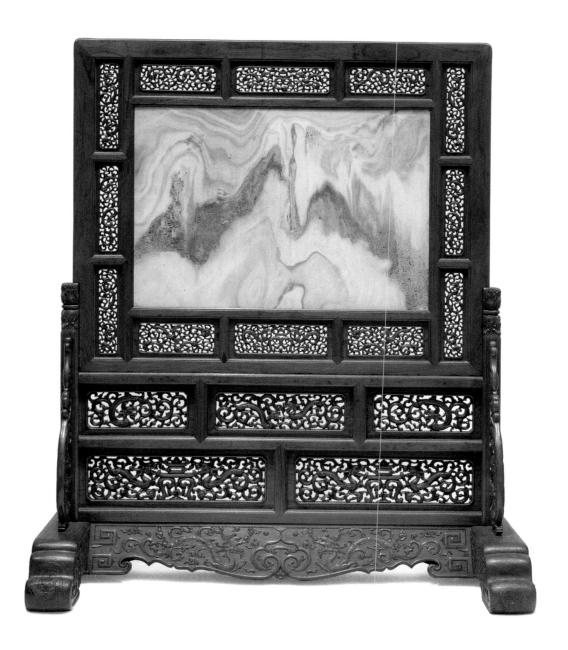

Large screens are probably the rarest category of surviving Ming-style furniture. Solid panel screens were placed inside the main entrance of buildings, where they provided privacy and protection from drafts and dispelled negative cosmic energy that might harm the occupants within. Screens such as this were also used behind the seats of important individuals. Marble panels from Yunnan province, evocative of mountainous landscapes in their natural figurations, were favorite insets for solid screens. This monumental work is distinguished by its rarity, the extraordinary quality of the surrounding carved frame, and the size and quality of the original marble inset. Considered by many to be the finest screen of its type in existence, it was purchased at auction in 1996 at a world-record price for a piece of Chinese furniture.

CHINESE,
MING OR EARLY CH'ING DYNASTY
Standing Screen with Marble Panel,
17th century
Huang-hua-li, tie-li-mu, and marble
Gift of Ruth and Bruce Dayton
96.120.7

KOREAN

Kuo Tzu-i's Banquet, 19th century

Ink and colors on silk

Gift of funds from

Fred and Ellen Wells

97.121.3

This large ten-panel folding screen, painted with fine, even lines and brilliant pigment, is an impressive example of the kind of work produced by professional artists to decorate the palaces and homes of high-ranking Korean aristocrats. The Chinese theme suggests Korea's strong admiration for its large and powerful neighbor.

The subject of the screen is a banquet in honor of general Kuo Tzu-i (697–781). Over the course of his long and distinguished military career, Kuo served under four emperors and was thus a paragon of Confucian virtue, having devoted his entire life to his lord and country. As a result, Emperor Ming Huang rewarded him with the title "prince." This screen shows the retired general surrounded by his eight sons and daughters, their wives and husbands, and many grandchildren and great-grandchildren, all enjoying the festivities staged within the palace gardens.

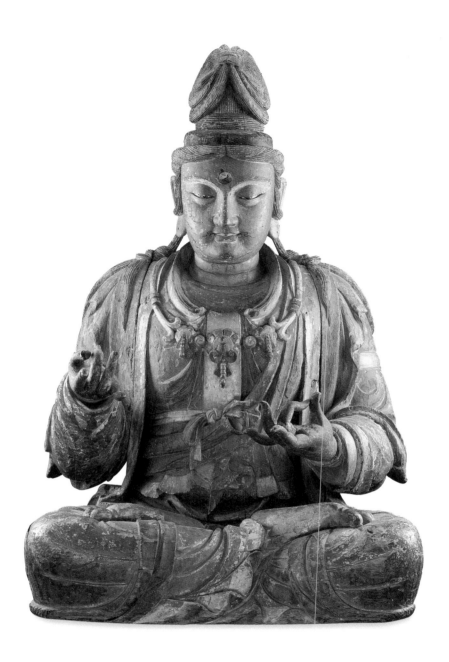

Bodhisattvas are Buddhist deities who have forgone entrance into Nirvana until that time when all beings have attained enlightenment. In China, Kuan-yin became the most popular *bodhisattva* and was widely worshipped as the deity of mercy and compassion.

This magnificent object from northern China is constructed of removable wooden sections that still retain traces of original pigment. Several parts of the robes exhibit fine textile patterns executed in gold. The figure is seated cross-legged in the pose of meditation, with the right hand raised in the gesture of charity and the left hand in the gesture of discourse or argumentation. Carved during the last creative epoch of Chinese Buddhist sculpture, this sumptuously attired image expresses the new humanism of the day and captures the calm of near enlightenment.

CHINESE, SUNG DYNASTY
The Bodhisattva Kuan-yin, late 11th–early 12th century
Wood, gesso, and mineral pigments
Gift of Ruth and Bruce Dayton
98.62

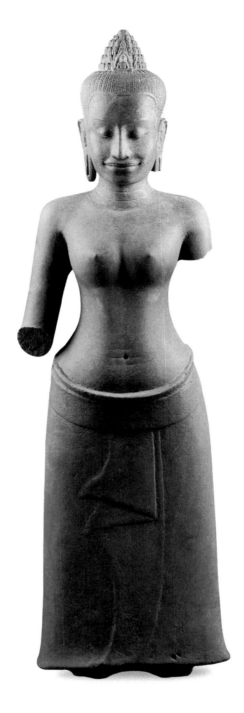

CAMBODIAN,
ANGKOR PERIOD
Prajnaparamita
(Goddess of Transcendent Wisdom),
about 1200
Gray sandstone
The John R. Van Derlip Fund
97.105

Recognizable by the seated Buddha at the base of her conical crown, this superb early Bayon-style figure represents Prajnaparamita, the Buddhist goddess of transcendent wisdom. With eyes closed in meditation, she expresses the supreme bliss that comes from perfection of wisdom. Her relaxed physiognomy and sublime expression convey a sense of mystic divinity.

This image is associated with a small group of Bayon period statues that are thought to represent Queen Jayarajadevi, the first wife of King Jayavarman VII (reigned 1181–1218). Legend has it that when the queen died prematurely, her older sister Indradevi commissioned statues of her in the guise of Prajnaparamita.

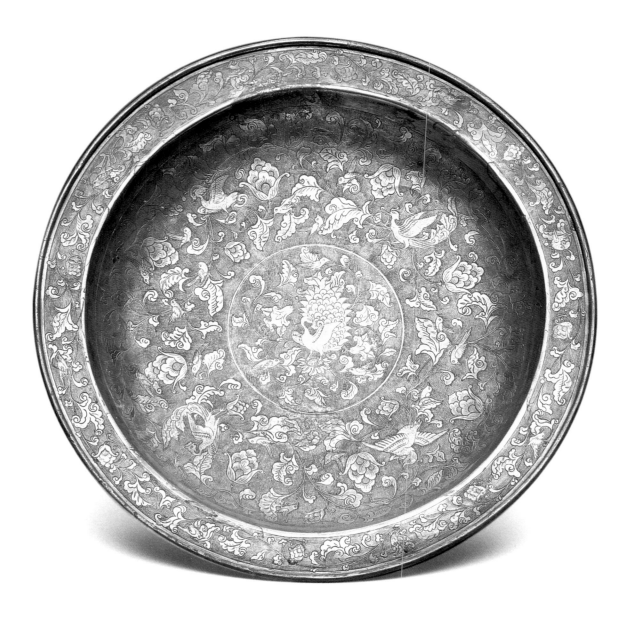

Few periods in Chinese history were as vital and glorious as the T'ang dynasty (618–907), a time of enormous prosperity and creativity in the visual and literary arts. Although gold and silver had been worked in China since the Shang dynasty (1900–1027 B.C.), the T'ang dynasty's precious metalwork in gold and silver overshadows that of all previous periods with its innovative shapes, delicate designs, and technical brilliance. This rare plate stands on three stump feet. The interior features a peacock standing on a lotus blossom at the center, surrounded by lotus scrolls, several varieties of birds, and leaves. The bird and tendril designs are enhanced with gilding, and the background is ringmatted.

CHINESE,

T'ANG DYNASTY

Plate, 8th century

Silver with chased and gilt decor

Gift of Mrs. Charles S. Pillsbury,

Phillip Winston Pillsbury, Mary

Stinson Pillsbury Lord, Katherine

Stevens Pillsbury McKee, and Helen

Winston Pillsbury Becker in memory

of Charles S. Pillsbury

51.28.3

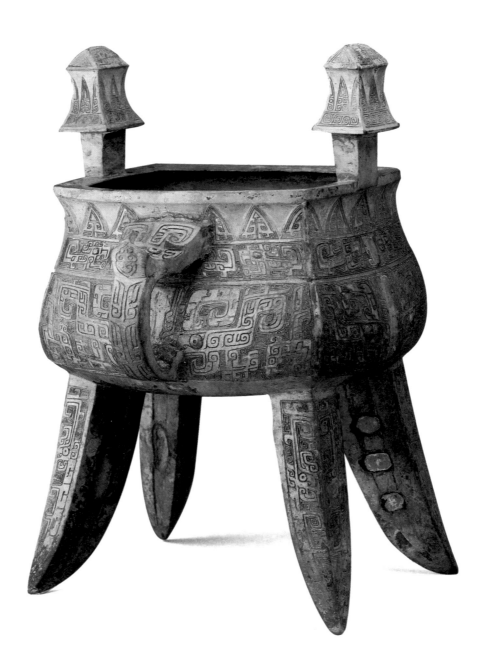

Most Shang dynasty bronzes are ritual wine or food vessels. This *chia*, made for heating wine, is exceptional for its taut profile, fine proportions, and exquisitely cast overall decor. The protective *t'ao-tieh* mask, standard on most Shang ceremonial vessels, appears in the largest register on all four sides of the cauldron. Profiles of beaked dragons decorate the outer side of each leg and the band encircling the neck. A frieze of rising blades, representing cicadas, is shown above this neck band and appears again in the main register of the two posts. A single, indecipherable character, most likely a clan ownership mark, is cast into the floor of the vessel.

...ully ornamented lacquer boxes with compartments for an ink-
...water dropper, and brushes, became popular during the Muromachi
...). By the Edo period, lacquer artists adroitly combined a variety of
...uce sumptuous objects of great visual appeal. For this box, the
...ay were rendered in silver, which has oxidized to a pewter-gray
..., too, is a silver disk, which would have flashed brilliantly against

JAPANESE,
EDO PERIOD
Writing Box with Moon and W—
18th century
Lacquer with *hiramaki-e* an—
Gift of Louis W. Hill, Jr.

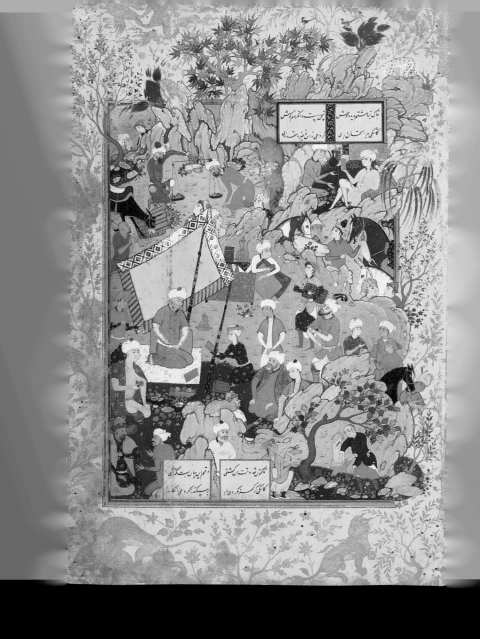

Depicting a king and his courtiers picnicking in a mountain gl[...]
example of late 16th-century Persian miniature painting. The [...]

...itains,

drawing of animals in the midst of lush gold foliage, the fine [...]
dynamic composition, and the decorative use of color perfec[...]

...iper

taste. The scene is drawn from the *Khamsa* (Five Poems) by N[...]

. Webber

Since Safavid court artists occasionally worked for the Mugh[...]
style of painting naturally influenced Islamic court painting[...]

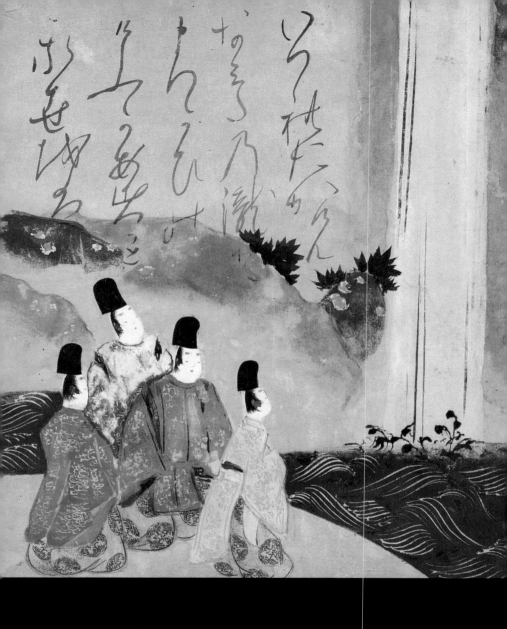

founders of the Rimpa school during the early 17th century, Sotatsu
by literary themes and painting styles from Japan's classical past. This
illustrates a scene from the *Ise Monogatari* (The Tales of Ise), a literary
written around 950. In it a group of noblemen enjoy the view of a
erfall. Sotatsu portrayed the 10th-century court nobles in a traditional
ng fine, even lines and stylized faces. He updated his composition, how-
ng a technique known as *tarashikomi*, in which darker pigments are applied
lighter colors, resulting in softly mottled, abstract landsc

TAWARAYA SOTATSU
JAPANESE, 1600–1640
Nobles Viewing the Nunobiki Wa
about 1634
Color on paper
The John R. Van Derlip F
66.40

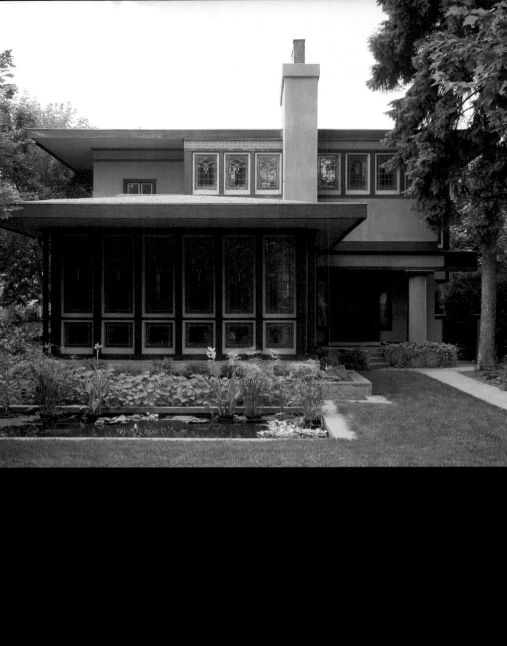

DECORATIVE ARTS
SCULPTURE AND
ARCHITECTURE
COLLECTION

The first two directors of The Minneapolis Institute of Arts, Joseph Breck and Russell Plimpton, came from the decorative arts department of the Metropolitan Museum of Art in New York. Not surprisingly, they established a strong tradition for decorative arts at this museum, assembling a series of European and American period rooms as contextual backdrops for the exploration of Western art history. The overall goal of the Department of Decorative Arts has been to put together a survey collection of objects, punctuated by masterpieces from ancient Egypt to the present. Collectors with specialized interests have provided greater depth in selected areas. For example, the collection is particularly strong in 17th- and 18th-century English and American silver thanks to James Ford Bell, whose many donations are featured in the newly designed Bell Family Decorative Arts Court and in the 1989 permanent collection catalogue *English and American Silver: The Collection of The Minneapolis Institute of Arts.*

In the 1970s and 1980s, the Groves Foundation funded the addition of a distinguished group of 18th-century decorative objects from France and England, including an important room from the Hôtel de la Bouexière in Paris from 1735 that will serve as a centerpiece after it is carefully restored. Another outstanding focused collection is represented by the MacFarlane Memorial Room, with its fine late 18th-century Chinese wallpaper and its 18th- and early 19th-century American Federal period furniture and accessories bequeathed by Mrs. Warren C. MacFarlane, with additional gifts from Mr. and Mrs. Wayne H. MacFarlane. Other significant collections include the French 18th-century faience donated by Mrs. John P. Rutherfurd, the 17th- and 18th-century English delft given by Mr. and Mrs. George R. Steiner, and the Chinese export porcelains from Leo and Doris Hodroff.

The focal point of midwestern decorative arts of the late 19th and early 20th century is the Purcell-Cutts house, a Prairie School gem that architect William Purcell designed for himself in 1913. The house, at 2328 Lake Place in Minneapolis, was bequeathed to the Institute in 1985 by Anson Cutts, the son of its second owner. Masterworks by Purcell's contemporaries, Louis Sullivan, Frank Lloyd Wright, and George Maher, are on view in the Institute's galleries.

WILLIAM GRAY PURCELL AND GEORGE GRANT ELMSLIE, ARCHITECTS

AMERICAN, 1880–1965 AND 1869–1952

Purcell-Cutts House, 1913

Bequest of Anson B. Cutts, Jr.; restoration funds provided by the Anson B. Cutts, Jr.,
Fund, Gabberts Furniture and Design Studio, Judy and Kenneth Dayton, the
Friends of the Institute, and the Decorative Arts Council

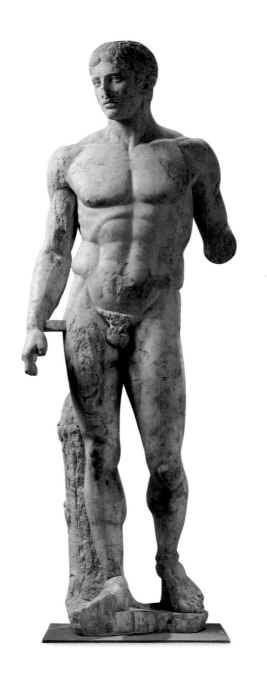

ROMAN, AFTER A 5TH-CENTURY B.C.
GREEK ORIGINAL

Doryphoros (Spear Bearer),
probably 1st century B.C.
Pentelic marble

The John R. Van Derlip Fund and gift
of Bruce B. Dayton, an anonymous
donor, Mr. and Mrs. Kenneth Dayton,
Mr. and Mrs. W. John Driscoll, Mr.
and Mrs. Alfred Harrison, Mr. and
Mrs. John Andrus, Mr. and Mrs.
Judson Dayton, Mr. and Mrs. Stephen
Keating, Mr. and Mrs. Pierce McNally,
Mr. and Mrs. Donald Dayton, Mr. and
Mrs. Wayne H. MacFarlane, and many
other generous friends of the Institute
86.6

This statue is the finest surviving version of a famous sculpture of antiquity, the *Doryphoros* of Polykleitos. The bronze original (long since lost) was made between 450 and 440 B.C., during the Classical period of Greek history, when Athens was the political, cultural, and commercial center of the Western world. The most renowned artists of the time were Pheidias, who designed the sculptures for the Parthenon, and Polykleitos, whose statues of young athletes exemplified the naturalistic ideal of Classical Greek art. The *Doryphoros* embodies Polykleitos's theories of rhythm and proportion.

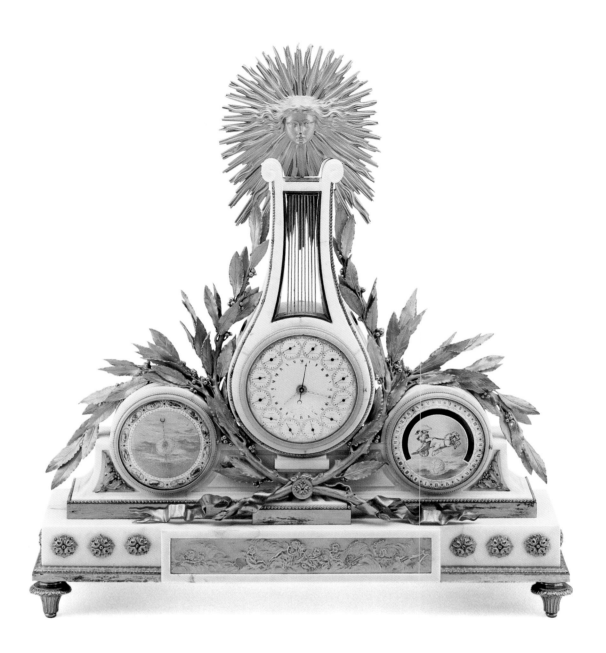

This is a notable example of a distinctive group of French clocks that contain intricate mechanisms. Throughout the 18th century, interest in precision timekeeping was stimulated by the needs of navigation and astronomy. Jean-Antoine Lepine made important contributions to horology, especially in the design of watch movements. Not surprisingly, several complicated clocks of this general configuration exist by Lepine. Two of these have royal associations, but the present example is by far the most complex. Its twelve subsidiary dials record the time in numerous European capitals, as well as localities as diverse as Batavia and Boston.

FRENCH

JEAN-ANTOINE LEPINE, 1720–1814

DIALS PAINTED BY JOSEPH

COTEAU, 1740–1812

Astronomical Mantel Timepiece, about 1789

Marble and gilt bronze

with enamel dials

Gift of Mrs. Carolyn Groves

88.88.1

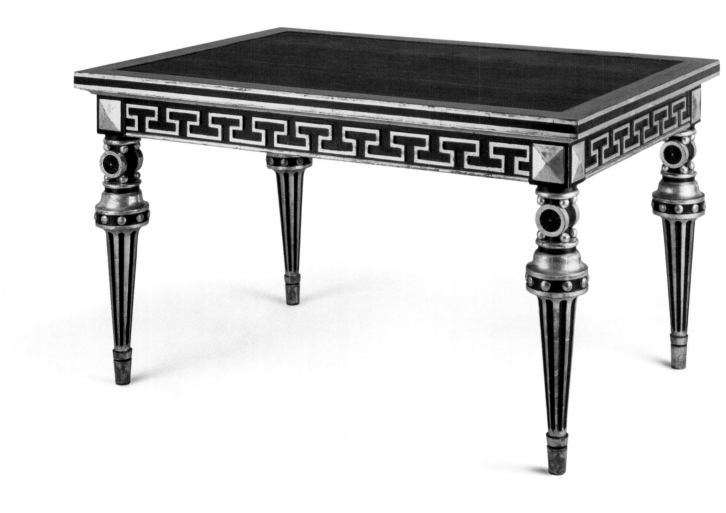

THOMAS HOPE

ENGLISH, 1769–1831

Library Table, about 1800

Oak, pine, paint, and gold leaf,

with inset canvas

Gift of the Friends of the Institute

96.32.1

Thomas Hope, the great tastemaker of Regency England at the beginning of the 19th century, endowed his tables and chairs with bold proportions and arresting silhouettes so they could hold their own amidst the important paintings and sculptures that filled his London residence on Duchess Street. An illustration of his picture gallery in the *Magazine of Fine Arts* in 1821 shows our table in the foreground. Old master paintings hang around it, including two already in the Institute's collection: Titian's *The Temptation of Christ* and Giorgio Vasari's *Six Tuscan Poets.*

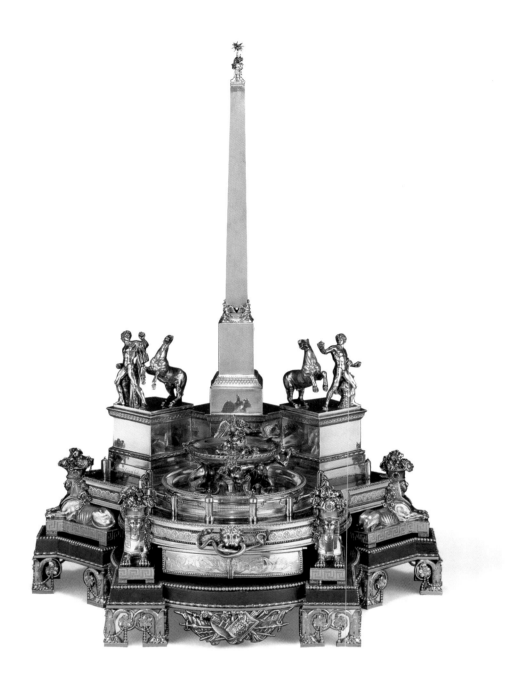

This inkstand commemorates the erection of the Quirinal Monument in Rome during the pontificate of Pius VI. The monument, which still stands in the piazza outside the Quirinal Palace, consists of two ancient Roman sculptures called the *Horse Tamers*, an Egyptian obelisk unearthed near the Mausoleum of Augustus, and a fountain taken from the Roman Forum. The inkstand, presented to the pope in April 1792, reproduces the monument in miniature, with marvelous ingenuity and craftsmanship. Moving a lever causes two turtledoves to come together. The sphinxes' headdresses lift out to disclose candleholders. A drawer opens, displaying an assembly of *trompe l'oeil* prints, including Coaci's trade card. The *Horse Tamers* slide out to reveal an inkwell and a sandbox. Although not shown here, a stamped and gilded leather traveling case shaped like a fortress was designed to protect the inkstand when not in use.

VINCENZO COACI
ITALIAN (ROME), 1756–94
*Inkstand Representing
the Quirinal Monument*, 1792
Silver, silver gilt, lapis lazuli,
and rosso antico marble
Gift of the Morse Foundation
69.80

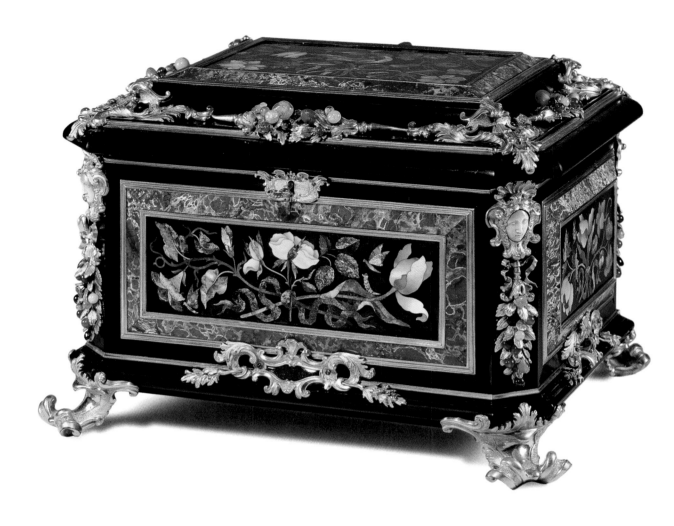

GIOVANNI BATTISTA FOGGINI,
DESIGNER
ITALIAN (FLORENCE), 1652–1725
Pietra Dure Jewelry Box, about 1700–1720
Oak, ebony, slate, lapis, agate,
and marble
Gift of Bruce B. Dayton
86.85

Pietra dure (Italian for "hard stones") describes the technique of decorating objects like this jewelry box with brightly colored stones, such as lapis lazuli, agate, and jasper. Carefully fitted together, the stones form intricate designs in two and three dimensions. Although practiced since antiquity, the art of *pietra dure* was revived during the Renaissance at a Florentine workshop founded by the Medici family in 1588. The workshop still operates today. In 1695, the sculptor, architect, and designer Giovanni Battista Foggini was appointed director of this workshop. He is known to have designed many *pietra dure* objects for Cosimo III de Medici to give as gifts to other members of the European nobility. This jewelry box is a rare surviving example of one of Foggini's designs.

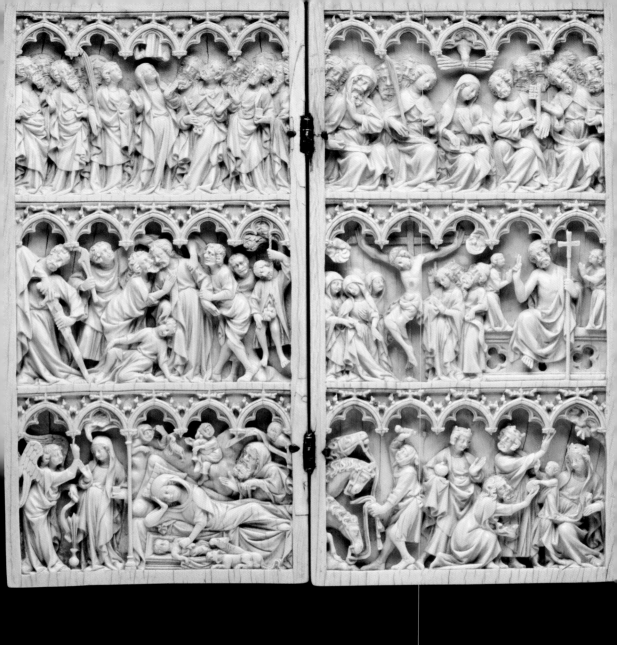

In the Middle Ages, particularly in France, ivory carvers produced exquisite reliefs and statuettes with both religious and secular subjects. This 14th-century diptych portrays scenes from the life of Christ, beginning in the bottom left-hand corner with the Annunciation and moving to the right with images of the Nativity and the Adoration of the Magi. The middle tier contains events of Christ's Passion: the Betrayal (with Judas hanged, at the right), the Crucifixion, and the Resurrection. Along the top are the Ascension of Christ and, finally, Pentecost, when the Holy Spirit (shown here as a dove bringing rays of light) descended to the apostles.

FRENCH

*Diptych with Scenes from
the Life of Christ,* about 1375
Carved ivory with traces of paint
Gift of Mr. and Mrs. John E. Andrus
Atherton and Winifred W. Bean, and a
anonymous donor
83.72

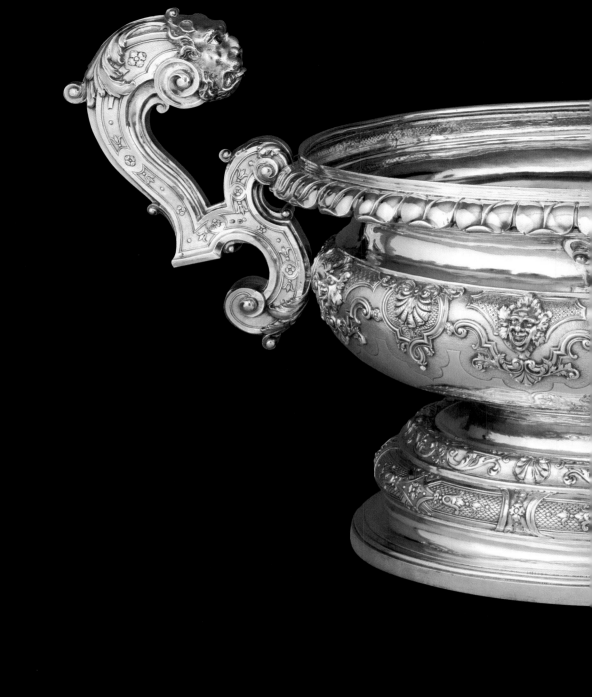

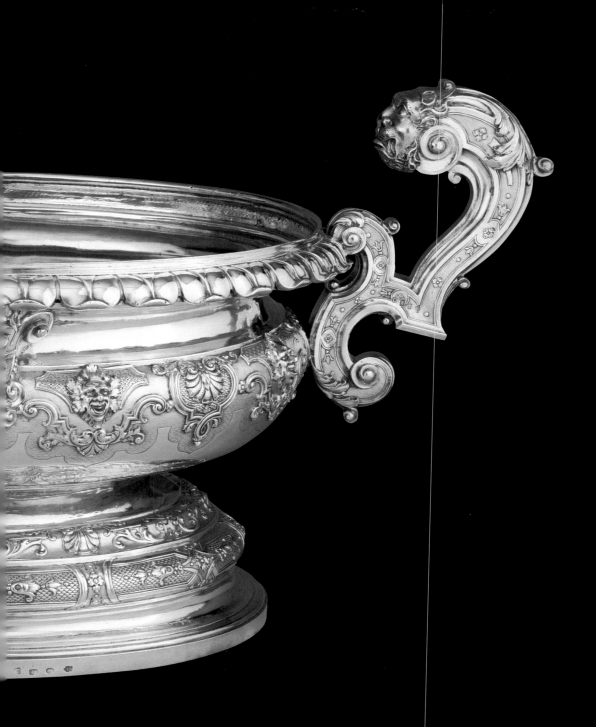

Paul de Lamerie was born in Holland to Huguenot parents who immigrated to England. He grew up in London and was apprenticed to Pierre Platel, an accomplished Huguenot silversmith who taught him to work in the ornate Baroque manner. At the age of twenty-four, de Lamerie was appointed goldsmith to the king. During those early years, he made this great wine cistern for John Leveson-Gower, first earl Gower. His grandson was created first duke of Sutherland in 1833, which explains the cistern's sobriquet. The massive elliptical basin was hammered from a single sheet of silver; the base, handles, molding, and ornamental detail were cast separately and soldered to the bowl. Floral, foliate, and figural motifs, from grinning fauns to seashells, embellish the surface, and the large handles each terminate in a lion's head. Wine cisterns held cold water for chilling bottles of wine.

PAUL DE LAMERIE
ENGLISH, 1688–1751
Sutherland Wine Cistern, 1719–20
Silver
The James S. Bell Memorial Fund
61.56

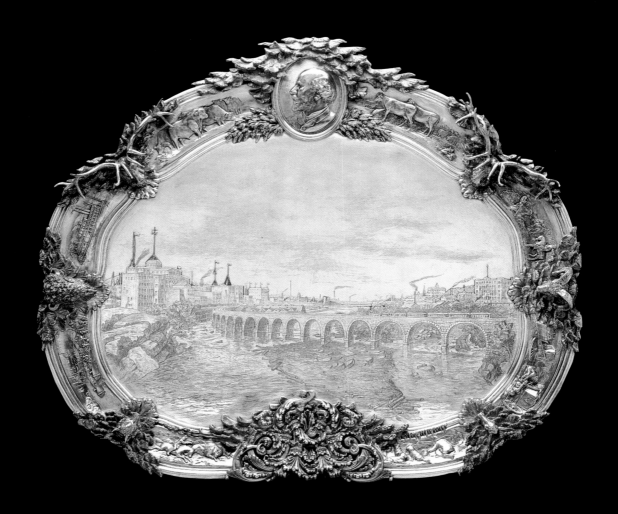

TIFFANY & CO.

AMERICAN (NEW YORK),

1837–PRESENT

Presentation Tray, 1884

Silver

Gift of Mr. and Mrs. G. Richard Slade

81.5

Seventeen prominent Minneapolis businessmen commissioned this tray for St. Paul railroad magnate James J. Hill upon the completion of the Stone Arch Bridge in 1883. As president and chief stockholder of the St. Paul, Minneapolis, and Manitoba Railroad, Hill had constructed the bridge, creating access to the heart of the city's business district for the first time. Recognized throughout the world as one of the great engineering feats of the 19th century, the bridge was a symbol of the city's prosperity and progress.

Narrative decoration was typical of 19th-century presentation silver. The large flat area in the center of this tray features a view of Minneapolis and the Stone Arch Bridge, and the perimeter contains eight vignettes of events from Hill's life.

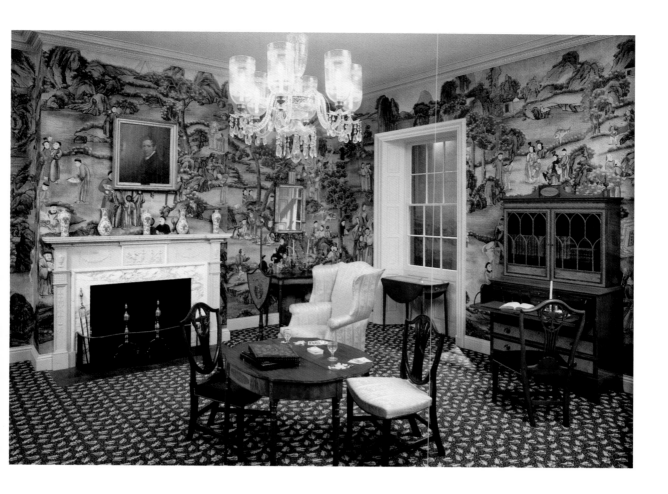

As a striking backdrop for her fine collection of New England Federal period
furniture and accessories, Mrs. Warren C. MacFarlane acquired a superb set of late
18th-century handpainted Chinese wallpapers from Nancy McClelland, the legendary
New York dealer in historic wallpapers and textiles. Their original context is uncer-
tain, but similar papers were known to have been imported for some of the finest
homes in Boston and nearby Salem, Massachusetts. The architectural detailing for
this room has most appropriately been inspired by that found in the first Harrison
Gray Otis House, built in Boston's fashionable West End in the 1790s from designs
by its leading architect, Charles Bulfinch. Since the dedication of the room in 1973,
Mrs. MacFarlane's son and daughter-in-law, Mr. and Mrs. Wayne H. MacFarlane,
have continued to make significant additions to her initial gift.

AMERICAN
MacFarlane Memorial Room, Boston, 1796
with *Chinese Export Wallpaper,*
late 18th century
Gift of Mrs. W. C. MacFarlane
in memory of her son,
Warren C. MacFarlane, Jr.

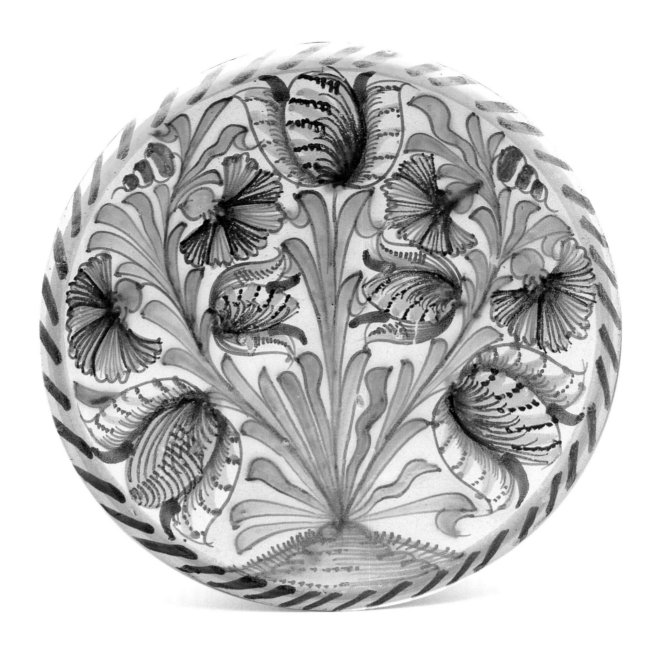

ENGLISH (LONDON)

Tulip Charger, about 1680

Tin-glazed earthenware

Gift of Mr. and

Mrs. George R. Steiner

96.36.2

This brightly painted tulip charger is among the best examples of its type. Known today as a "blue-dash" charger because of the thick strokes of blue pigment around the rim, the dish shows the influence of Isnik pottery imported from Turkey. Pigments of bright turquoise green, blue, yellow, and red are typical of Isnik wares, as are the dense patterns of stylized tulips and carnations. Large decorative platters such as this were rarely functional; they were used primarily for display, often on the tops of dressers, or were hung on dark paneling to provide a bright spot of color.

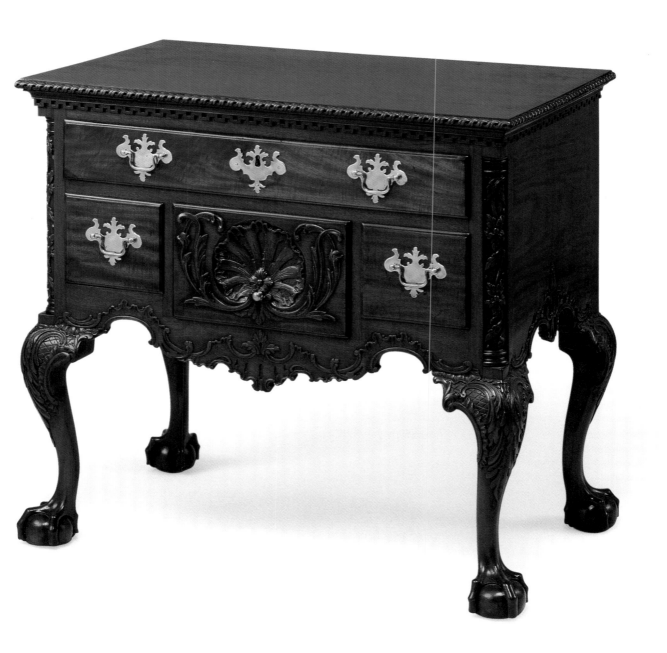

A dressing table like this one and a matching tall chest of drawers were often the most elaborate pieces of furniture in a wealthy Colonial home. The carving on this piece is exceptional and has recently been attributed to the Garvan carver, one of the most important American carvers of the 18th century. The name of this unknown Philadelphia craftsman is derived from a similar set of furniture in the Mabel Brady Garvan collection at Yale University.

AMERICAN (PHILADELPHIA)
Dressing Table, about 1760–80
Mahogany and white pine
Gift of James F. and Louise H. Bell
in memory of
James S. and Sallie M. Bell
31.21

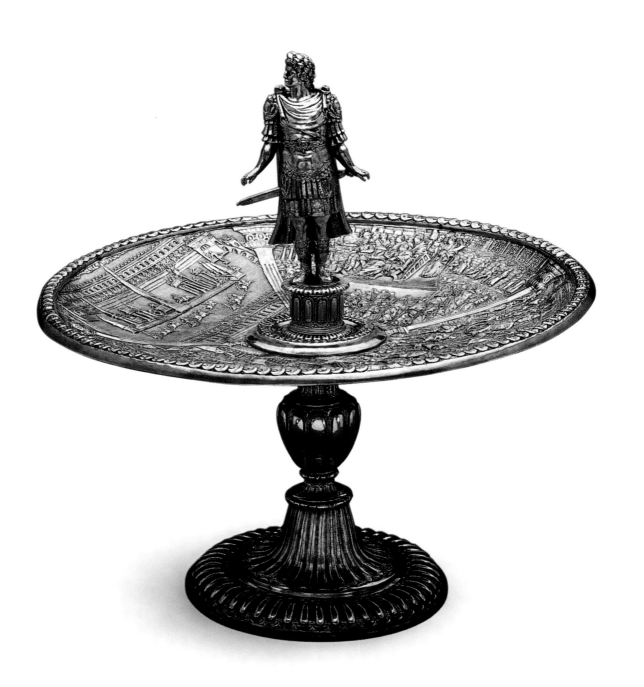

ITALIAN

Tazza, about 1570–80

Silver gilt

The James Ford Bell Family

Foundation Fund, the

M. R. Schweitzer Fund, and the

Christina N. and Swan J. Turnblad

Memorial Fund

75.54

During the 15th century, the *Lives of the Caesars* by Suetonius, a Roman of the second century A.D., became an indispensable volume in every Renaissance library. It is a biography of the first twelve Roman emperors, from Julius Caesar to Domitian. This tazza belonged to a set of twelve ornamental cups inspired by the book. Each featured a different emperor rising from the center and important events of his reign in low relief on the inside of the shallow bowl. At a later date, the set was dismantled and then incorrectly reassembled. As a result, the Institute's tazza combines the finely detailed image of Augustus with scenes from the life of Caligula.

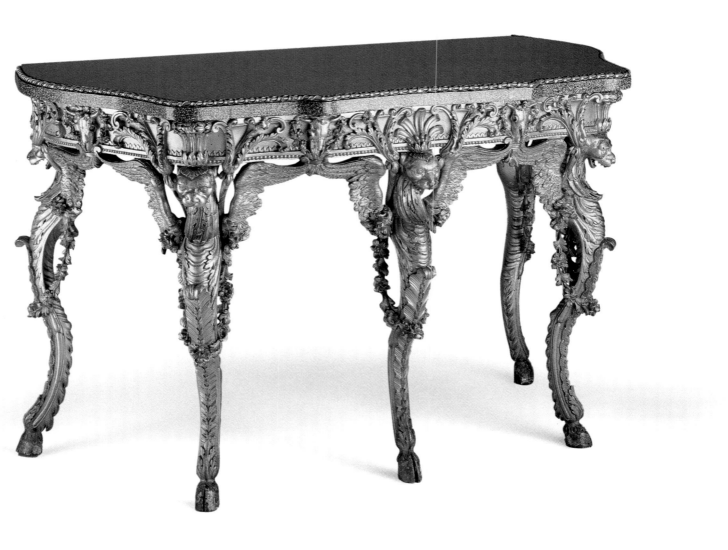

This table is perhaps the most widely known piece of furniture in the Institute's collection. Piranesi's design for it appeared in his publication *Diverse Maniere...* (Different Fashions...), a volume of engravings completed in 1769 that contained his designs for a number of household furnishings. Designed for the state apartments in the Quirinal Palace in Rome of Cardinal Giovanni Battista Rezzonico, nephew of Pope Clement XIII, the table features winged chimeras, goat skulls, hoofed feet, and palmettes taken directly from classical sources. This table and its mate, which is now in the Rijksmuseum in Amsterdam, are the only surviving pieces of furniture designed by Piranesi.

GIOVANNI BATTISTA PIRANESI
ITALIAN (VENICE), 1720–78
Side Table, about 1769
Carved and gilded oak and limewood, marble top
The Ethel Morrison Van Derlip Fund
64.70

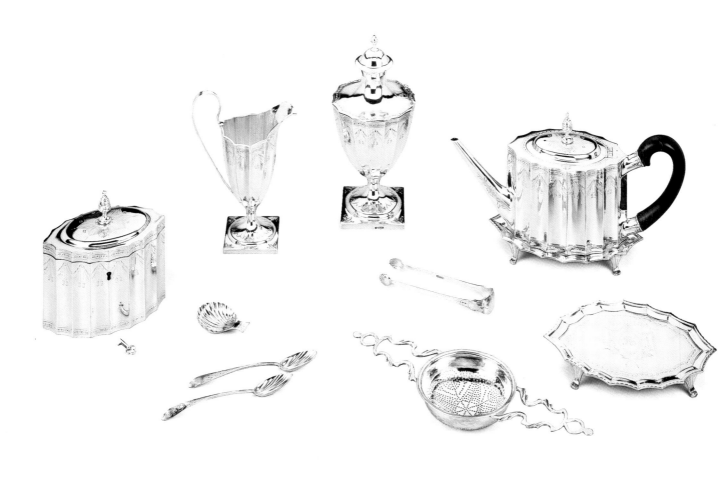

PAUL REVERE II

AMERICAN (BOSTON), 1735–1818

Tea Service, 1792–93

Silver

Gift of James F. and Louise H. Bell

60.22.1–9

Teaspoons gift of

Charlotte Y. Salisbury

94.88.1,2

Though best known as the patriotic horseman who roused the Minutemen to action in 1775, Paul Revere was also a successful silversmith and engraver and a dentist, merchant, and industrialist. He established a foundry that produced some of the first bells cast in this country and operated a mill for rolling sheet metal. This is the most complete surviving silver tea service of the Boston silversmith. It was originally commissioned by John Templeman of Boston. The cylindrical forms of the teapot and caddy were made from sheets of silver with lapped and riveted seams. This was easier than hammering a shape from a flat disk of silver, the process used for the creamer and sugar urn.

An expensive commodity in early America, tea was often kept locked in a caddy. The caddy in this set is one of two known examples made by the Revere shop. The teaspoons were only recently reunited with this set.

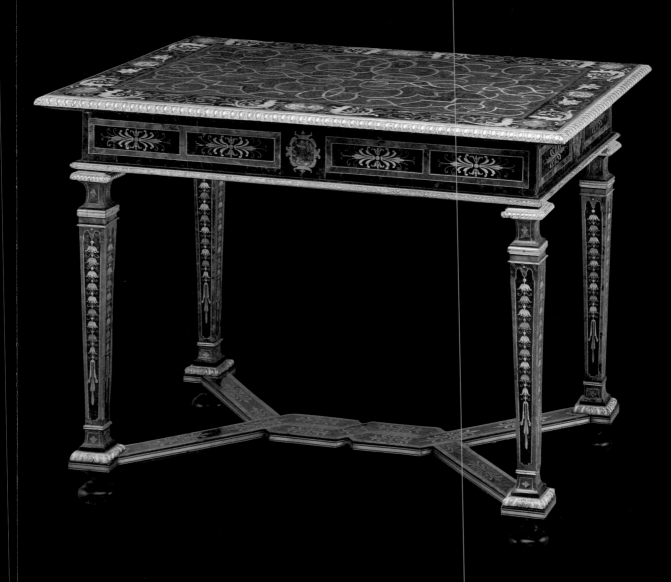

Marquetry is a method of decorating furniture by gluing onto the surface thin sheets of mosaics made from wood, ivory, tortoiseshell, metal, or other materials. Hans Daniel Sommer, a specialist in fine marquetry, received numerous commissions from wealthy German aristocrats, but few of those pieces have survived. This table, the most important piece of German Baroque furniture in the museum's collection and the only example of Sommer's work outside of Germany, is one of only three by Sommer in existence. It is a tour-de-force of arabesque patterning, with intricate pewter designs on a red tortoiseshell ground and a border of flowers and *putti* formed of brass, marble, horn, and ebony. The legs and interlaced stretchers are covered with similar marquetry. This sumptuous table would have stood in the center of a room, a testament to the owner's wealth and discriminating taste.

Hans Daniel Sommer
German, 1643–after 1685
Center Table, about 1690
Marquetry of tortoiseshell, brass, pewter, stone, horn, ebony, and mother-of-pearl
Gift of Atherton and Winifred W. Bean and the John R. Van Derlip Fund
80.55

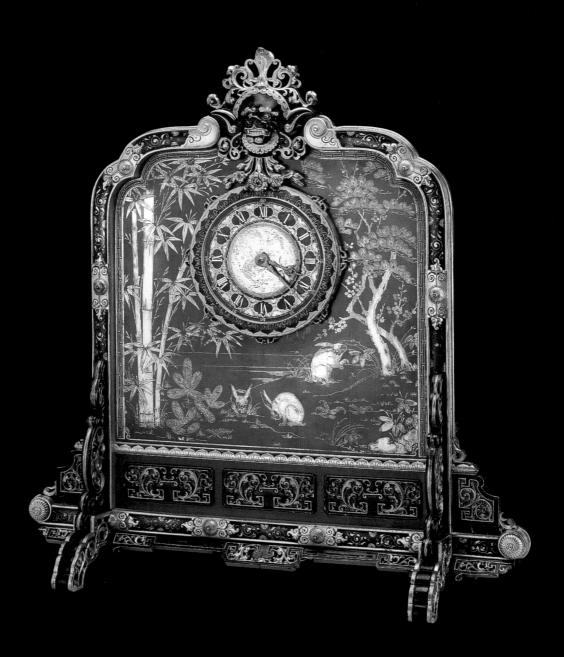

EMILE-AUGUSTE REIBER,
DESIGNER
FRENCH, 1826–93
CHRISTOFLE & CIE,
MANUFACTURER
PARIS, 1830–PRESENT
Clock, about 1869
Patinated and gilded cast bronze
with silver-inlaid copper panels
Gift of the Decorative Arts Council
96.72

This ornate clock vividly illustrates the earliest Japanese influences on European decorative arts following the reopening of Japan to the West in 1854, after 200 years of seclusion. The clock combines European, Japanese, and other Asian motifs and styles. Its overall form was derived from an 18th-century Chinese table screen; the face and the whimsical beast above it were inspired by Tibetan mandalas; and the exquisite inlay on the central panels depicts scenes taken from Japanese paintings, lacquerwork, and ceramics. The clock's designer, Emile-Auguste Reiber, directed the design studio at Christofle & Cie from 1864 to 1878.

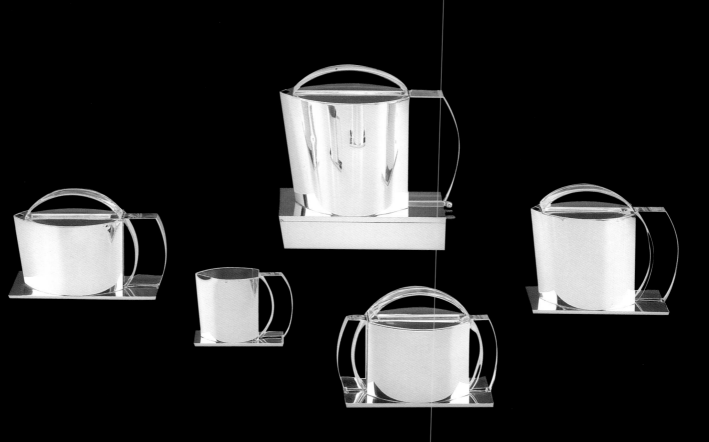

The bold, streamlined forms and shining surfaces of this magnificent coffee and tea service epitomize the Art Deco style and the work of prominent French silver-smith Jean Puiforcat. Although painstakingly made by hand, the pure silver and optical glass forms embody the machine aesthetic emulated by Art Deco designers. Puiforcat and other designers of the 1920s looked to aerodynamic shapes used in modern industry as sources, concentrating on form, rather than ornament, in their construction.

JEAN PUIFORCAT
FRENCH, 1897–1945
Coffee and Tea Service, 1925
Silver and optical glass
Decorative Arts Department
deaccession funds, the
Putnam Dana McMillan Fund, and
gift of the Decorative Arts Council
94.71.1–5

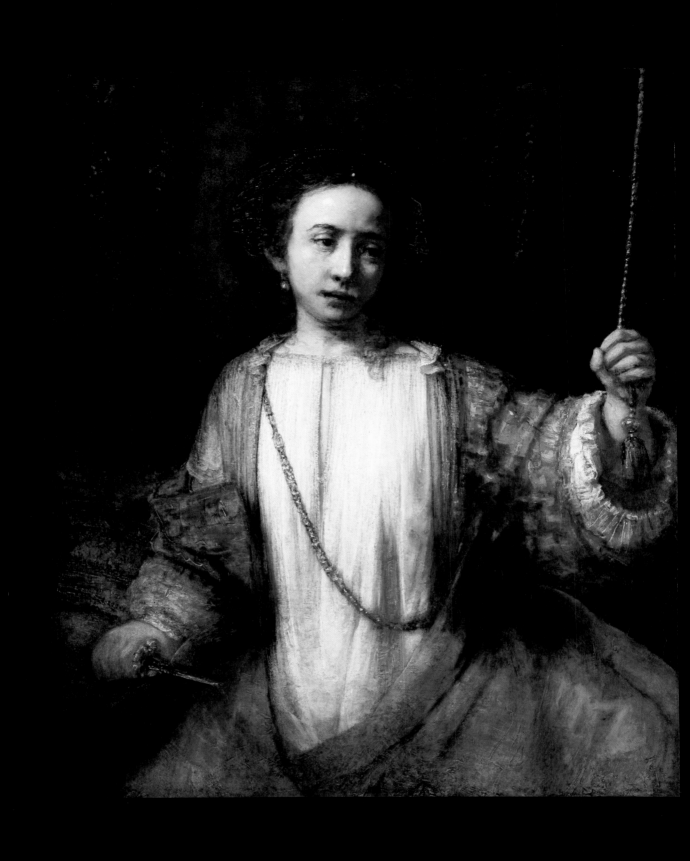

PAINTINGS COLLECTION

The Institute's internationally acclaimed collection of paintings contains nearly 900 European and American works from the 14th century to the present. It offers a comprehensive survey of both celebrated schools and individual artists and is notable for its concentration of masterworks.

One of the museum's earliest acquisitions was Gustave Courbet's *Deer in a Forest*, which St. Paul railroad magnate James J. Hill donated in 1914. Hill's collection of 19th-century French Romantic and Realist art was exceptional. After his death, many of his most important pictures, including Eugène Delacroix's *The Fanatics of Tangier*, were given or bequeathed to the Institute by his descendants.

The present paintings collection, however, is not the consequence of any one person's vision; rather, it has been expanded in varied and often delightfully unpredictable ways by a succession of astute trustees, donors, directors, and curators. In addition to the French 19th-century pictures, the museum has rich holdings of Italian Baroque, 17th-century Dutch, and Fauve, Cubist, and German Expressionist works. The American collection showcases a range of artistic accomplishments from Gilbert Stuart to Larry Rivers and contains exceptional paintings by John Singer Sargent and Georgia O'Keeffe.

The pictures selected to illustrate this commemorative book are but a sample, albeit a breathtaking one, of the Western paintings visitors can discover in the Institute's reinstalled third floor paintings galleries.

REMBRANDT VAN RIJN

DUTCH, 1606–69

Lucretia, 1666

Oil on canvas

The William Hood Dunwoody Fund

34.19

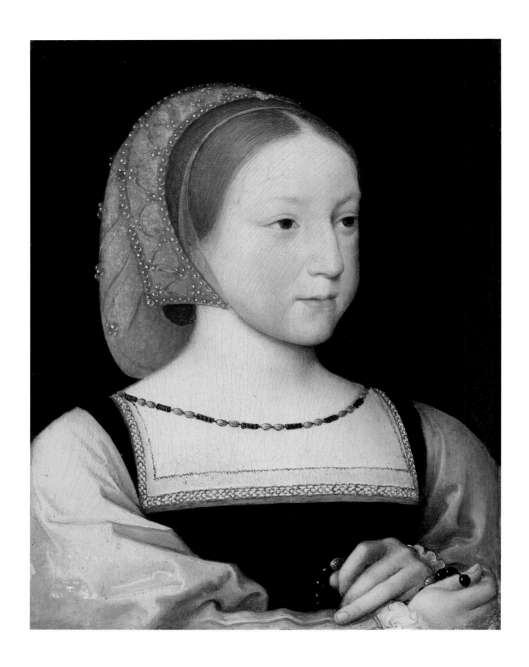

JEAN CLOUET THE YOUNGER
FRENCH, 1475–1541
Princess Charlotte of France, about 1522
Oil on panel
Bequest of John R. Van Derlip
in memory of
Ethel Morrison Van Derlip
35.7.98

Francis I, a contemporary of Charles I of Spain and Henry VIII of England, governed France from 1515 to 1547 and made his court an international center for humanistic studies and the arts. Leonardo da Vinci, Andrea del Sarto, and Benvenuto Cellini worked there, as did French artists like Jean Clouet, who painted this portrait of Francis's daughter Charlotte. One of seven children by her father's first marriage, Charlotte was born in 1516 and died at the age of eight.

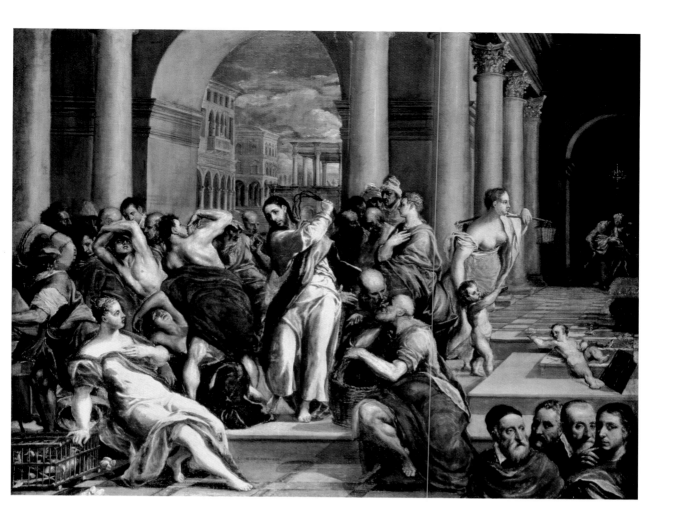

A Greek who studied in Italy and settled in Spain, El Greco was one of the principal masters of European Mannerism. This painting, one of several versions of the subject, depicts Christ's anger at finding the temple used as a marketplace and stable. In the lower right corner are portraits of the four artists who most influenced El Greco—Titian, Michelangelo, Giulio Clovio, and Raphael.

EL GRECO (DOMÉNIKOS
THEOTOKOPÓULOS)
SPANISH, 1541–1614
*Christ Driving the Money Changers
from the Temple,* about 1570
Oil on canvas
The William Hood Dunwoody Fund
24.1

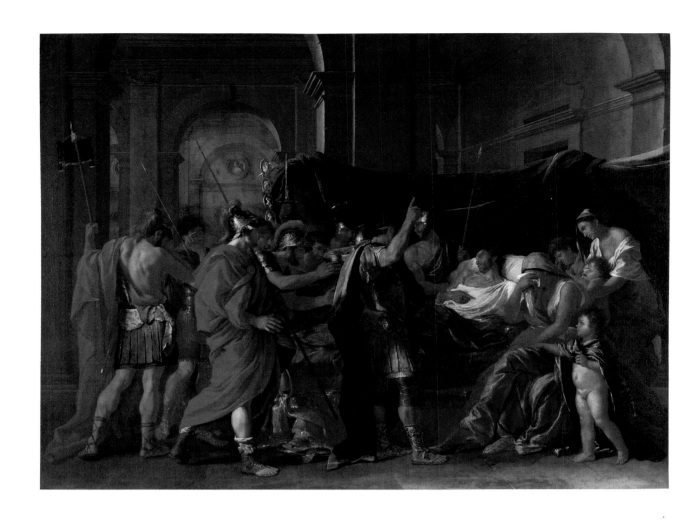

Nicolas Poussin

French, 1594–1665

The Death of Germanicus, 1627

Oil on canvas

The William Hood Dunwoody Fund

58.28

Poussin's study of antique art and the paintings of Raphael and Titian led him to formulate a new classicism, based on order, clarity of design, and moral rectitude, which became the credo of the French Royal Academy when it was established in 1648. Commissioned in 1627 by the Italian cardinal Francesco Barberini, this was Poussin's first major history painting. It is based on Tacitus's account of the death of the Roman general Germanicus, who was poisoned in A.D. 19, probably by his jealous and insecure uncle, the emperor Tiberius. Surrounded by his soldiers and grieving family, Germanicus swears his followers to revenge and receives an oath of allegiance from his successor.

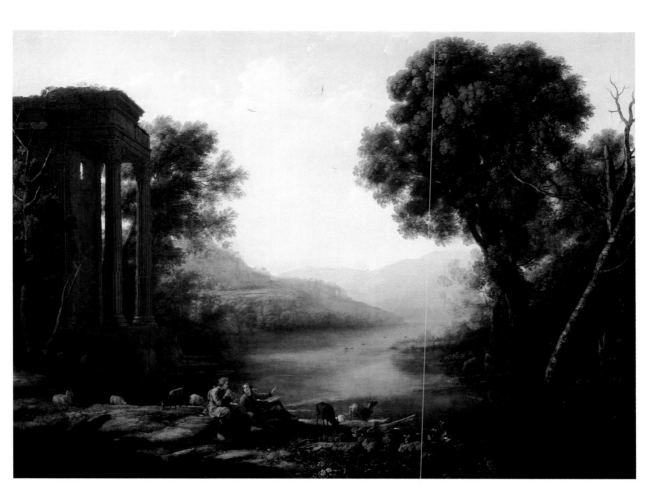

A masterwork of Claude's first mature style, *Pastoral Landscape* (Liber Veritatis 23) was painted in Rome for the French diplomat Etienne Gueffier (1576–1660). Through most of the last two centuries, it has remained in the collection of the Earls of Leitrim, which undoubtedly accounts for its exceptional state of preservation. This painting is resplendent Claude in its archetypal nostalgia for the simplicity of lost arcadian life and its naturalistic fascination with color, light, and atmosphere. As a work of pure landscape, it aptly complements the Institute's seminal early Poussin, *The Death of Germanicus.*

CLAUDE LORRAIN

FRENCH, ABOUT 1603–82

Pastoral Landscape, 1638

Oil on canvas

98.33

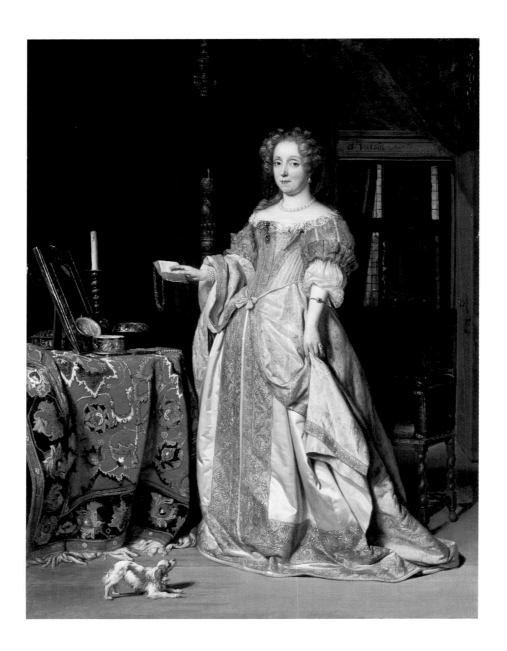

GABRIEL METSU

DUTCH, 1629–67

Portrait of a Lady, 1667

Oil on panel

Gift of Atherton and

Winifred W. Bean

92.16

Dating to the last year of Metsu's tragically short life, this exquisitely preserved panel shows the elegant and ornate style the artist was developing in response to trends in contemporary Dutch portraiture at the time. Although unidentified, the sitter was a woman of wealth and status, as suggested by the opulence of her dress and furnishings.

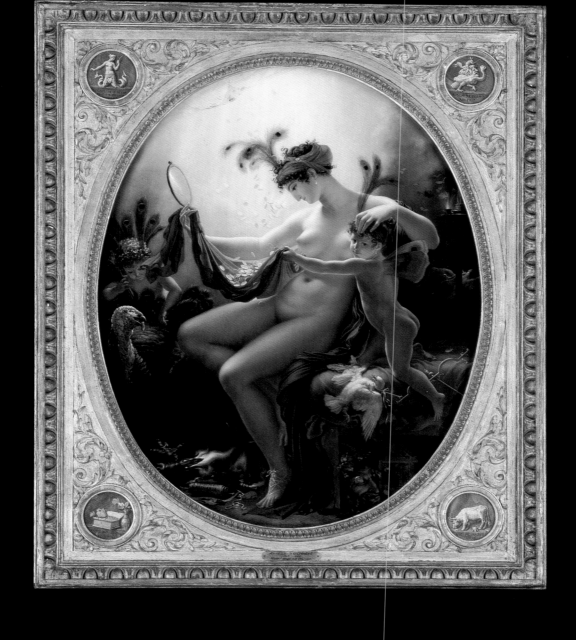

Danaë was one of the many mortals loved by the Olympian god Zeus, who came to her in the form of a shower of gold. For Girodet, this myth was the vehicle for a vicious satire of Mademoiselle Lange, a well-known Parisian actress. Girodet had painted a legitimate portrait of Lange, which she rejected as unflattering and for which she refused to pay. In retaliation, the artist painted this second likeness, showing her as a vain, greedy, and faithless prostitute. The painting caused a scandal when it was unveiled at the Salon of 1799.

ANNE-LOUIS GIRODET
DE ROUCY TRIOSON
FRENCH, 1767–1824
Portrait of Mademoiselle Lange as Danaë, 179
Oil on canvas
The William Hood Dunwoody Fund
69.22

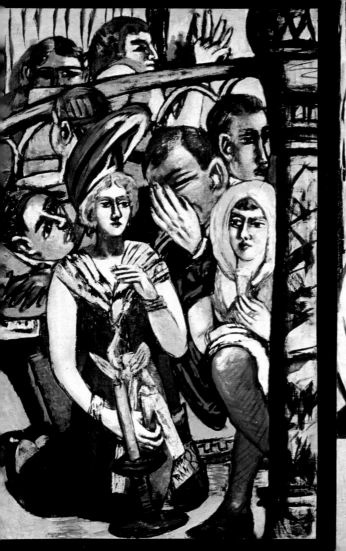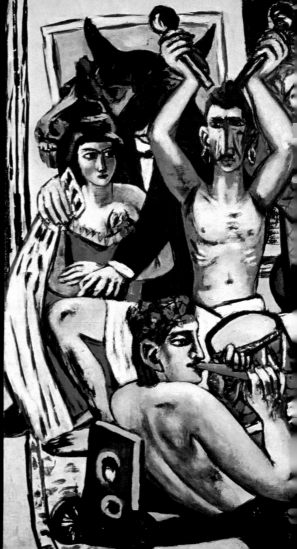

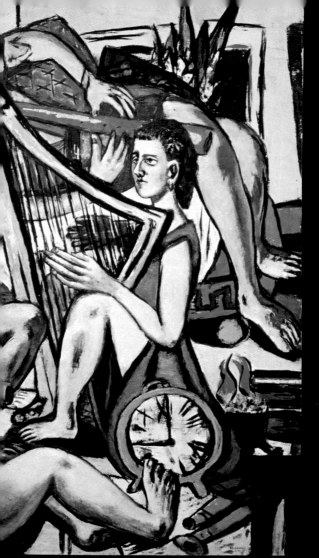
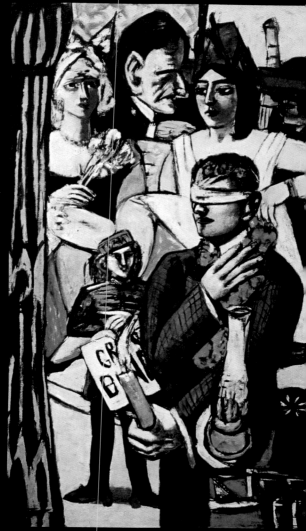

Branded as degenerate by the Nazis, Beckmann and his wife left Berlin in 1937 to visit a relative in Holland. They never returned. For the next ten years they lived mainly in Amsterdam, where Beckmann executed five of the nine triptychs that are his most important paintings. The triptych (three-paneled) format was traditional in medieval and Renaissance altarpieces and thus has religious associations. Beckmann called the figures in the central panel "the gods" and the animal-headed man the "minotaur." The garlanded Grecian piper, the drummer, the harpist, and the pipe player on the couch form a quartet that comprises both the classical and the barbaric, the erotic idyll and crude sensuality. They call the tune in this cabaret where people seek amusement in carnal pleasures. The blindfolded man and kneel-ing woman in the wings are posed deliberately to recall portraits of donors in

MAX BECKMANN
GERMAN, 1884–1950
Blindman's Buff, 1945
Oil on canvas
Gift of Mr. and Mrs. Donald Wins
55.27.1–3

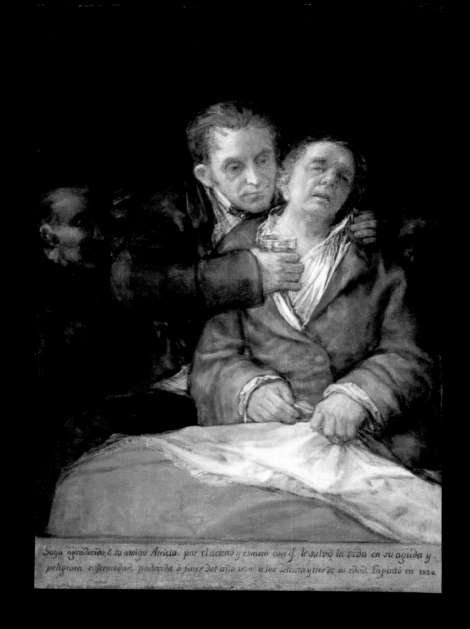

Goya agradecido, à su amigo Arrieta: por el acierto y esmero con q. le salvó la vida en su aguda y
peligrosa enfermedad, padecida à fines del año 1819. à los setenta ytres de su edad. Lopintó en 1820.

Francisco de Goya

Spanish, 1746–1828

Self-Portrait with Dr. Arrieta, 1820

Oil on canvas

The Ethel Morrison Van Derlip Fund

52.14

As court painter to both Charles III and Charles IV of Spain, Goya achieved considerable fame as a portraitist. This work, the last of his many self-portraits, was executed late in his life. In 1819, Goya fell seriously ill and was nursed back to health by his doctor, Eugenio García Arrieta. On recovering, he presented Arrieta this painting, which shows the physician ministering to his patient. In translation, the words at the bottom read, "Goya gives thanks to his friend Arrieta for the expert care with which he saved his life from an acute and dangerous illness which he suffered at the close of the year 1819 when he was seventy-three years old." This inscription gives the canvas the look of an ex-voto, a type of religious painting still popular in Spain, which expresses gratitude for deliverance from a calamity.

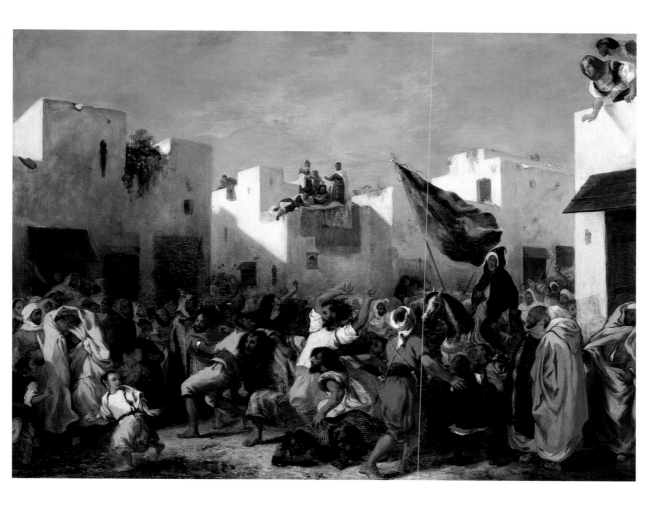

Eugène Delacroix was the acknowledged master of the French Romantic school. In 1832, he traveled to North Africa with the French ambassador, Count de Mornay, who was to negotiate a treaty of friendship with the sultan of Morocco. One day in Tangier, the two hid in an attic and through the cracks of a shuttered window witnessed the frenzy of the Aïssaouas, a fanatical Muslim sect. The turmoil of that event is conveyed in this vividly colored and vigorously brushed depiction of the fanatics hurling themselves down the street. Of the pictures resulting from the artist's Moroccan experiences, this remains one of the most arresting.

EUGÈNE DELACROIX
FRENCH, 1798–1863
The Fanatics of Tangier, 1838
Oil on canvas
Bequest of J. Jerome Hill
73.42.3

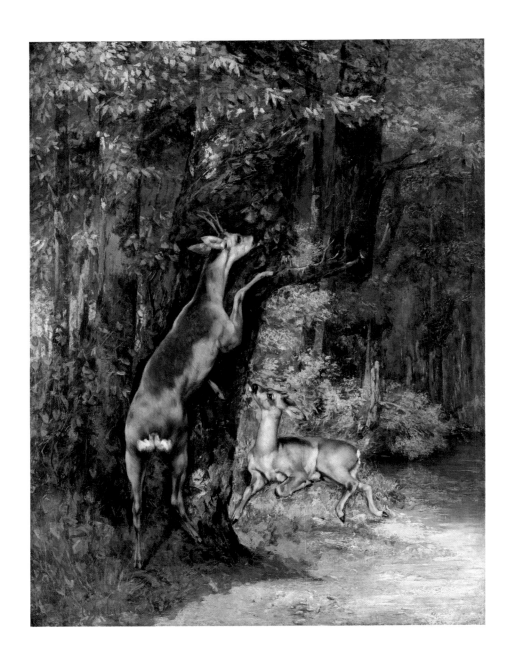

GUSTAVE COURBET

FRENCH, 1819–77

Deer in the Forest, 1868

Oil on canvas

Gift of James J. Hill

14.76

An enthusiastic sportsman, Gustave Courbet began to specialize in forest and hunting scenes during the late 1850s. A late work intended for the art market, *Deer in the Forest* once belonged to James J. Hill, the Minnesota railroad magnate whose collection of European paintings forms the basis of the Institute's 19th-century holdings.

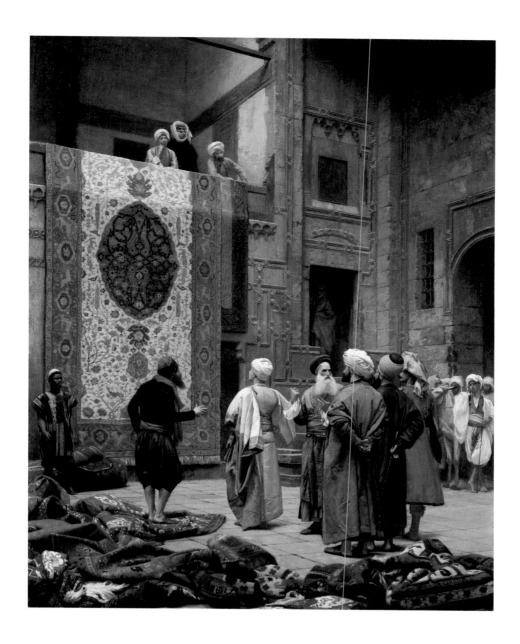

Schooled at the Ecole des Beaux-Arts and honored by the French Salon, Jean-Léon Gérôme was a prolific and popular artist. Like Delacroix, he traveled extensively in North Africa and the Middle East. *The Carpet Merchant* depicts the Court of the Rug Market in Cairo, which Gérôme had visited in 1885. Set within an imposing architectural framework, the animated scene displays the incisive detail, saturated colors, and skillful rendering of texture for which Gérôme was famous.

Jean-Léon Gérôme
French, 1824–1904
The Carpet Merchant, 1887
Oil on canvas
The William Hood Dunwoody Fund
70.40

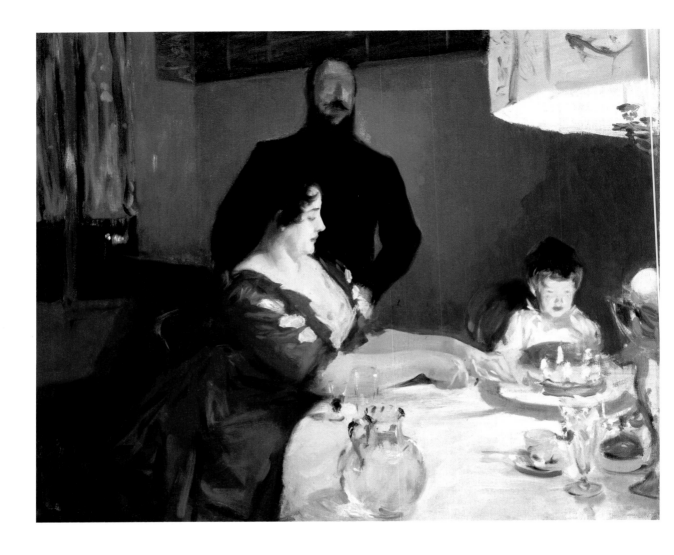

JOHN SINGER SARGENT
AMERICAN, 1856–1925
The Birthday, 1887
Oil on canvas
The Ethel Morrison Van Derlip Fund
and the John R. Van Derlip Fund
62.84

This vivaciously painted domestic subject is from a group of similar interior scenes that Sargent completed in the 1880s featuring portraits of his friends. It depicts the family of the well-known French artists Albert Besnard (1849–1934) and his wife Charlotte Dubray (1855–1931), with whom Sargent was on intimate terms by 1883.

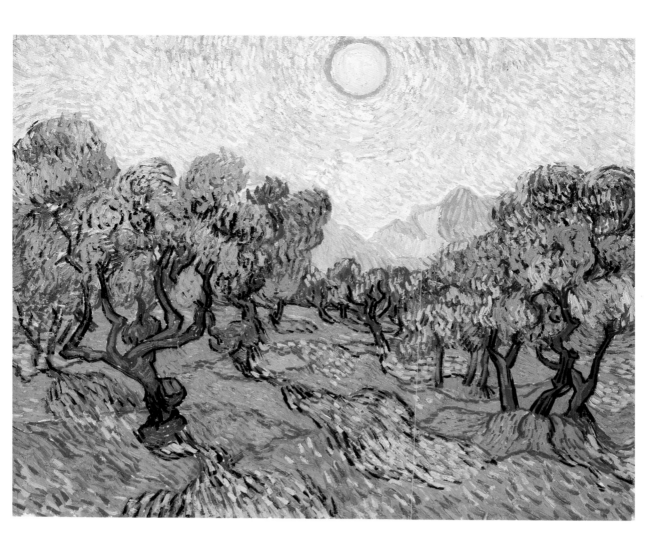

This is one of fifteen canvases of olive trees that van Gogh executed between June and December of 1889. Earlier that year he had interned himself in the asylum of St-Paul, in the town of St-Rémy in southern France, where he would create his most profound works. The intense color and heavy impasto of these canvases are typical of his style. The vibrant oranges and yellows suggest that the picture dates to the autumn months. Van Gogh left St-Rémy in May 1890, moving to Auvers, near Paris, where he continued to paint until his death by suicide in July.

VINCENT VAN GOGH
DUTCH, 1853–90
Olive Trees, 1889
Oil on canvas
The William Hood
Dunwoody Fund
51.7

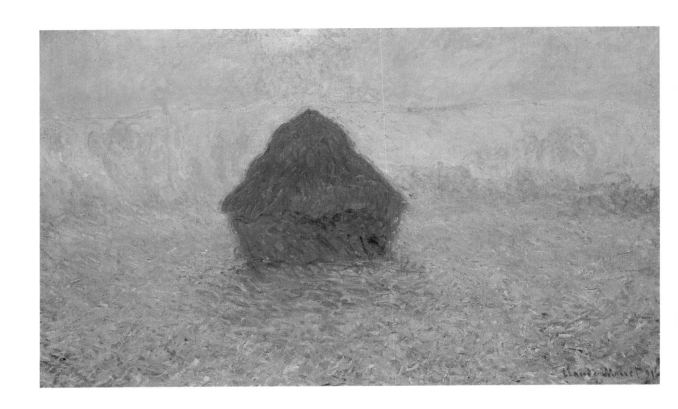

CLAUDE MONET

FRENCH, 1840–1926

Grainstack, Sun in the Mist, 1891

Oil on canvas

Gift of Ruth and Bruce Dayton, the
Putnam Dana McMillan Fund, the
John R. Van Derlip Fund, the William
Hood Dunwoody Fund, the Ethel
Morrison Van Derlip Fund, Alfred and
Ingrid Lenz Harrison, and Mary Joann
and James R. Jundt

93.20

In the late 1880s, Claude Monet studied visual perception by representing the same subject under varying conditions of light, atmosphere, and weather. In one series, he depicted the grainstacks near his house in Giverny, capturing them during different seasons. This picture shows the autumn dawn, at a moment when the sun burns off the rising mist. Up close, a flickering patchwork of broken brushstrokes can be seen, each one a notation of light. From a distance, the colors coalesce into a brilliant, shimmering image.

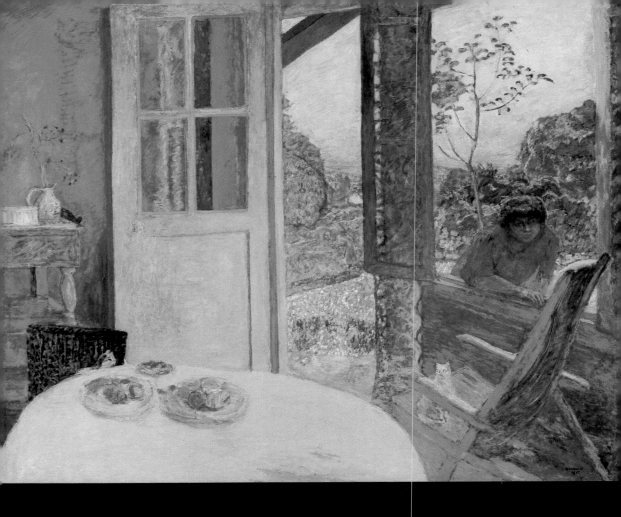

Pierre Bonnard considered himself "the last of the French Impressionists," but he
developed his own style, combining a distinctive sense of color with an appreciation
for the decorative qualities found in Japanese art and in the work of Paul Gauguin.
This painting depicts the dining room of Ma Roulotte (My Gypsy Caravan), the
artist's country house on the Seine at Vernonnet. The woman leaning on the win-
dowsill is probably Marthe de Méligny (Maria Boursin), whom Bonnard met in

PIERRE BONNARD

FRENCH, 1867–1947

Dining Room in the Country, 1913

Oil on canvas

The John R. Van Derlip Fund

54.15

Francis Bacon

English, 1909–92

Study for Portrait VI, 1953

Oil on canvas

The Miscellaneous Works of Art Fund

8.35

The human figure was Francis Bacon's principal object of study throughout his career. This picture belongs to a series of eight paintings that began as a portrait of Bacon's friend and biographer David Sylvester but became, in the end, studies of a seated pope. Inspired by Eadweard Muybridge's sequential photos of the human body in movement, Bacon made his figures more and more agitated until, in the final painting, the pope is convulsive. Here his ambiguous facial expression rests somewhere between the grimace of *Portrait V* and the horrific scream of *Portrait VII*.

René Magritte was a Surrealist painter fascinated by puzzles and paradoxes.
The Promenades of Euclid presents the age-old problem of illusion versus reality. In
this witty picture within a picture, the canvas in front of the window seems to
exactly replicate the section of city it blocks from view. In discussing a similar
work, Magritte explained: "The tree represented in the painting hid from view the
tree situated behind it, outside the room. It existed for the spectator, as it were,
simultaneously in his mind, as both inside the room in the painting, and outside
in the real landscape. Which is how we see the world: we see it as being outside
ourselves even though it is only a mental representation of it that we experience
inside ourselves."

RENÉ MAGRITTE
BELGIAN, 1898–1967
The Promenades of Euclid, 1955
Oil on canvas
The William Hood Dunwoody F
68.3

PHOTOGRAPHY
COLLECTION

Begun in 1973, the Institute's collection of photographs spans the history of the medium as fine art, from the 1860s to the present. More than 7,500 items strong, the collection consists primarily of 20th-century American work, but increasing emphasis on photographs from all countries is providing new scope and dimension to our already rich and diverse holdings.

The Department of Photography has developed and continues to thrive because of the active and generous support of loyal donors. Notably, the very earliest acquisitions were funded by Kate Butler and Hall James Peterson. Their initiative inspired others, including Harry Drake, Martin Weinstein, and Fred and Ellen Wells. The Petersons continued gifts for nearly six years formed the core of the collection. More recently, the creation of the Alfred and Ingrid Lenz Harrison Fund, along with the establishment of the Harrison Photography Galleries, has given the department enormous momentum. These superb new galleries are devoted to the presentation of our permanent collection.

Over the years, the Department of Photography has been committed to using the collection for educational purposes, and the Institute now serves as a major resource for the five-state area. Numerous exhibitions drawn from the collection have also traveled to smaller institutions, and high school and college students frequently visit our galleries and print study area.

Eugène Atget

French, 1857–1927

Storefront, Avenue des Gobelins, 1925

Aristotype

Gift of Roberta C. DeGolyer

86.103

WILLIAM HENRY FOX TALBOT

ENGLISH, 1800–1877

Cloisters of Lacock Abbey, 1844

Calotype

The John R. Van Derlip Fund

74.12

William Henry Fox Talbot invented one of the first successful methods of securing an optically produced image. He called the process Talbotype. This image is generically a calotype, a sensitized paper print made from the original paper negative. Because it is a contact print, its size is determined by the negative. Though small, the image conveys the quiet, contemplative charm of Lacock Abbey, Fox Talbot's ancestral home, and the formal dignity of his friend and fellow artist, scientist, and inventor, the Reverend Calvert Jones.

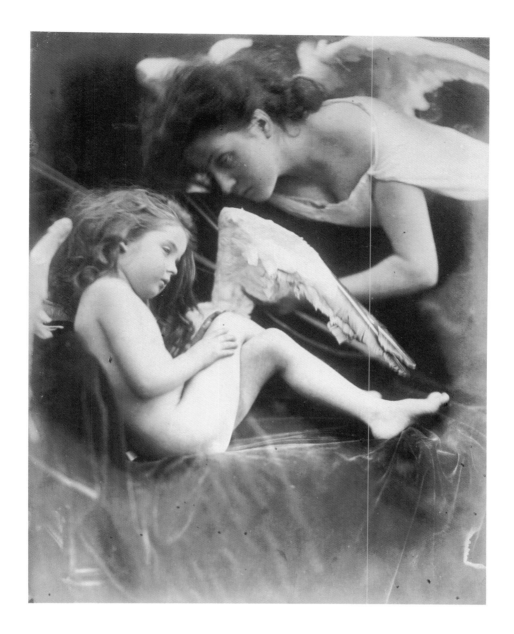

Thoroughly familiar with English portrait painting, lyric poetry, and classical mythology, the artistocratically born and bred Cameron confected her charming and highly imaginative allegories and portraits using family members and friends as sitters. She began her photographic career in her late forties, making numerous portraits of leading artistic, literary, and scientific people of the time, most of whom were personal friends. She and Alfred Lord Tennyson collaborated on an edition of his *Idylls of the King*, possibly the first example of a photographically illustrated literary publication in England.

JULIA MARGARET CAMERON

ENGLISH, 1815–79

Venus Chiding Cupid and Depriving Him
of His Wings, 1872

Albumen print

The Alfred and

Ingrid Lenz Harrison Fund

95.16.2

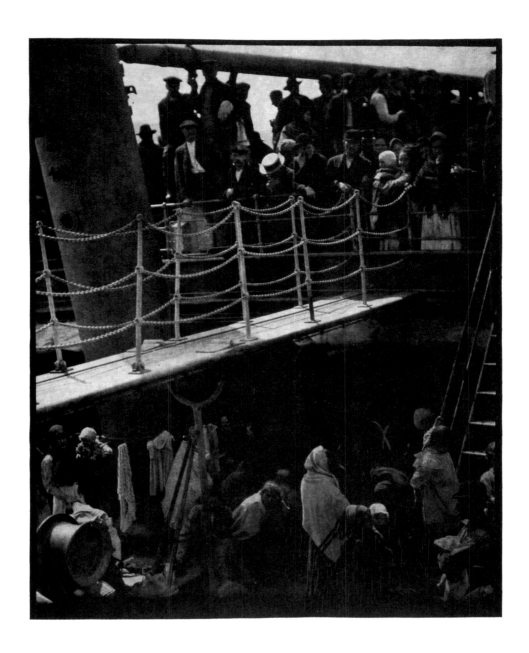

On one of his periodic voyages to Europe, Stieglitz ventured to the steerage section of the passenger ship from his less-frugal quarters and made this very modernist photograph with his 4- by 5-inch Graflex camera. Initially, he exhibited a contact print of the image but eventually made 13- by 10-inch gravure prints after colleagues encouraged him to do so. This has since become Stieglitz's most well-known and celebrated image. It is said that Pablo Picasso saw this picture and exclaimed that of all American artists, Stieglitz understood Cubism best.

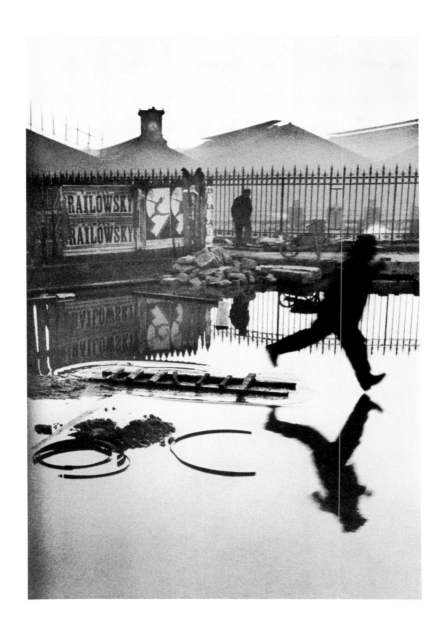

Since the mid-1930s, Henri Cartier-Bresson's photographs have had a universal influence on candid photography. Along with Robert Capa, David Seymour, and George Roger, Cartier-Bresson helped to establish the photography agency Magnum in Paris after World War II. From the beginning, Cartier-Bresson was also devoted to drawing, which may account for the strict, disciplined geometry of his crystalline photographs. With its spontaneous images of the human condition, his 1952 book *The Decisive Moment* proved instrumental in the development of modern photography.

HENRI CARTIER-BRESSON
FRENCH, 1908
Behind the Gare Saint-Lazare, Paris, 1932
Gelatin silver print
The Alfred and
Ingrid Lenz Harrison Fund
95.6.28

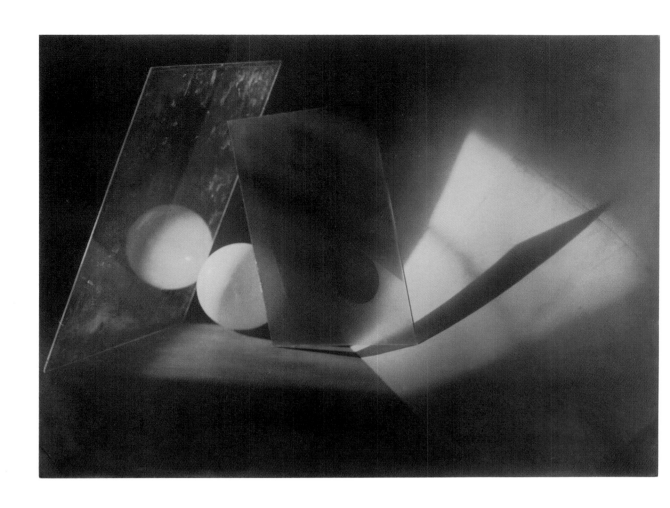

JAROMIR FUNKE

CZECHOSLOVAKIAN, 1896–1945

Still Life with a Little Ball, 1923

Gelatin silver print

The Alfred and

Ingrid Lenz Harrison Fund

93·45

In the 1920s, Funke produced a striking series of "shadow plays" and still lifes that explored the abstract nature of the photographic medium. At first he made photograms—images that resulted from laying objects on photographic paper and exposing it to light. Later he used a camera to photograph machine-made materials, such as paper, board, glass, mirrors, bottles, and balls. A few of these objects are the subject of this modernist still life. Two sheets of glass are mysteriously balanced next to a ball and a curving sheet of paper. All the shapes are geometric and non-organic, and the effect is an almost abstract pattern of light and shadow. Much of what is visible—reflections, shadows, and light itself—lacks a physical presence. In the 1930s Funke continued to explore abstraction and dynamic diagonals, photographing natural subjects found outdoors. But his later images were not nearly as challenging as his fabricated still lifes.

é Breton, Marcel Duchamp, Tristan Tzara, and others, Man Ray

Rudnitsky) was a key figure within the Dada and Surrealist move-

the 1920s and 1930s. He worked in several mediums but made his

tions in photography. This Rayograph, his personalized term for

s a primary example of his brilliant reinvention of this cameraless

rtist arranged ordinary objects on a sheet of photographic paper in

d then briefly flashed on a light. The unique developed photograph

at the usual lens, camera, and film negative, a pure fulfillment of

photography is "drawing with light." Man Ray's friend Tzara wrote

"istan" or "islam," a play on his own first name, with his finger on

e paper immediately before its exposure to light.

MAN RAY

AMERICAN, 1890–197

Tristan / Islam, 1924

Gelatin silver print

The Alfred and

Ingrid Lenz Harrison Fu

96.24

© Man Ray Trust, ADAG

ARS New York

I

..N ITALY, 1896–1942
teer, Mexico City, 1926
nt
rs. Patrick Butler Fund

Before becoming a student and protégé of the great California p
Edward Weston, Modotti was a minor theater and silent film sta
in San Francisco, she traveled to Mexico and Berlin in the 1920s a
became consumed by political causes and activities. The images s
her remarkable seven-year photographic career are fraught with politi
When her radical convictions compelled her to abandon photog
"I cannot solve the problem of life by losing myself in the proble

This green pepper is from a series of photographs of common garden vegetables, including squash, eggplant, and radishes. Weston successfully elevated these mundane subjects to monumental, archetypal stature through the power of visualization. He and his friend Ansel Adams were key figures in a pivotal exhibition that included "f64" in its title, a reference to the very small lens aperture required for extremely sharp optical resolution. Weston claimed to relish first photographing, and later consuming, his subjects.

Lewis W. Hine

American, 1874–1940

Empire State Building, New York City,

about 1930

Gelatin silver print

The Ethel Morrison Van Derlip Fund

92.61

Hine is recognized mainly for his photographs of children in grueling and often dangerous working conditions in factories, coal mines, and on farms throughout the industrial and rural Southeast. He made these pictures on behalf of the National Child Labor Commission. On occasion, though, his images were not so sociologically probing. To capture this picture, he perched himself among the girders to show steelworkers constructing the Empire State Building. Hine later became the inspiration and philosophical and artistic mentor for the politically oriented Film and Photography League, an organization committed to photography in the service of social change.

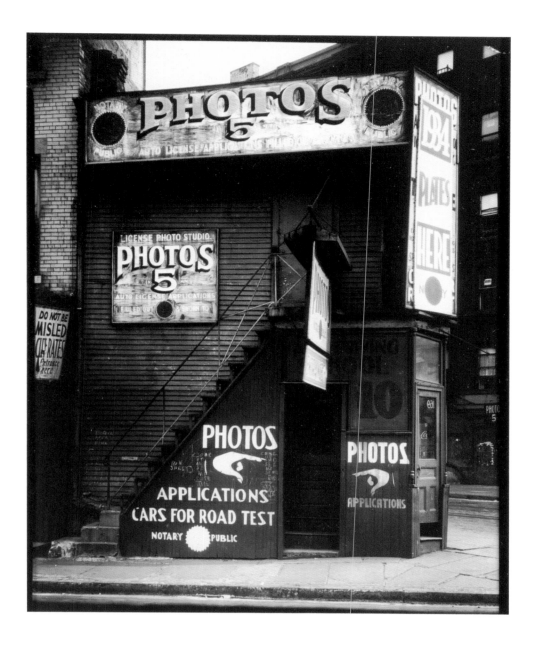

Evans, who made images in what he called the documentary style, may be considered the archetypal photographer of ordinary places, people, and indigenous architecture. Taken throughout the United States, his pictures are distinguished by their literary irony and Evans' formal structural sense and unerring mixture of sophistication and observation. As a photographer and a professor at Yale University, Evans had a profound effect on the tone, substance, and direction of photography in America.

WALKER EVANS

AMERICAN, 1903–75

License Photo Studio, New York, 1934

Gelatin silver print

Gift of Arnold H. Crane

75.42.1

ALEXANDER RODCHENKO

RUSSIAN, 1891–1956

Ossip Brik, 1924

Gelatin silver print

Gift of Daniela Mrázková

93.36.2

A key figure in the Russian Constructivist movement, Alexander Rodchenko used the camera to explore a radical new way of visualizing the social and political world he was immersed in. Other tools Rodchenko and his colleagues used to fashion a new vision included graphic and industrial design, architecture, painting, and theatrical set design.

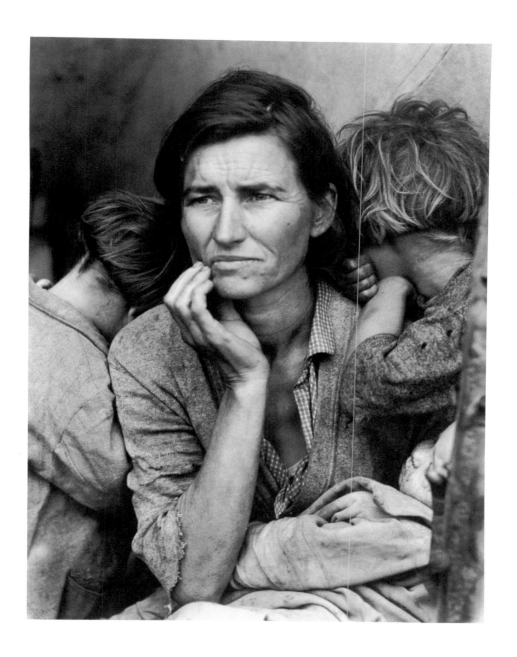

In the 1930s and 1940s, Lange was hired by the Farm Security Administration to document the plight of farmers and migrant workers in drought-ravaged rural America. Other photographers, including Walker Evans, Russell Lee, and Arthur Rothstein, photographed similar subjects for the FSA, but none with more compassion and humanity than Lange. Her maternal instincts brought a level of emotional authority and comprehension to her photographs that was not found in her colleagues' images. Because she worked closely with her husband, Paul Taylor, an economist and government field worker, Lange had a special grasp of the relentless economic forces that determined and tormented the lives of those she photographed.

Dorothea Lange
American, 1895–1965
Migrant Mother, Nipomo, California, 1936
Gelatin silver print
The Alfred and
Ingrid Lenz Harrison Fund
92.136

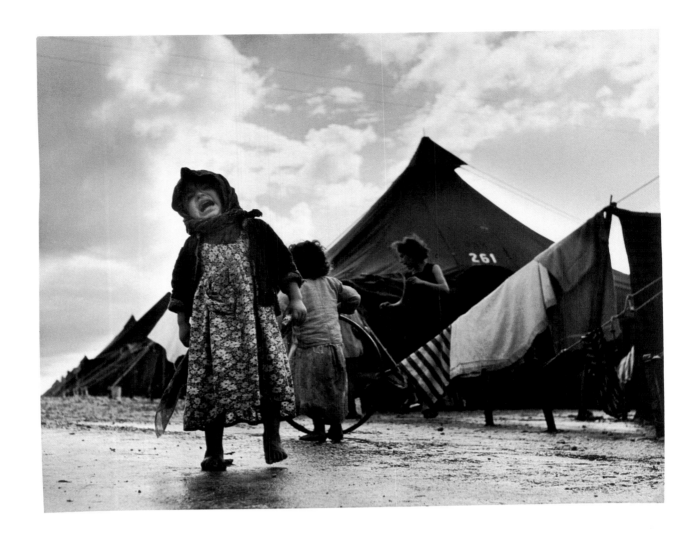

ROBERT CAPA

AMERICAN, BORN HUNGARY,

1913–54

Rosh Hay'n Internment Camp, Shaar Aliyah,

near Haifa, Winter, October–November, 1950

Gelatin silver print

The Alfred and Ingrid Lenz

Harrison Fund

L98.89.7

During World War II, Robert Capa gained acclaim as the most celebrated war photographer of all time. And through his frequent contributions to *Life* magazine, he became a role model for subsequent photojournalists. Along with Henri Cartier-Bresson, David Seymour, and George Roger, Capa helped found the legendary photo collective Magnum in Paris in 1947. Capa's death in Vietnam in 1954 made him the first American photojournalist to perish in that tragic conflict. His hundreds of photographs and several books continue to provide compelling testimony about the horrors and waste of war.

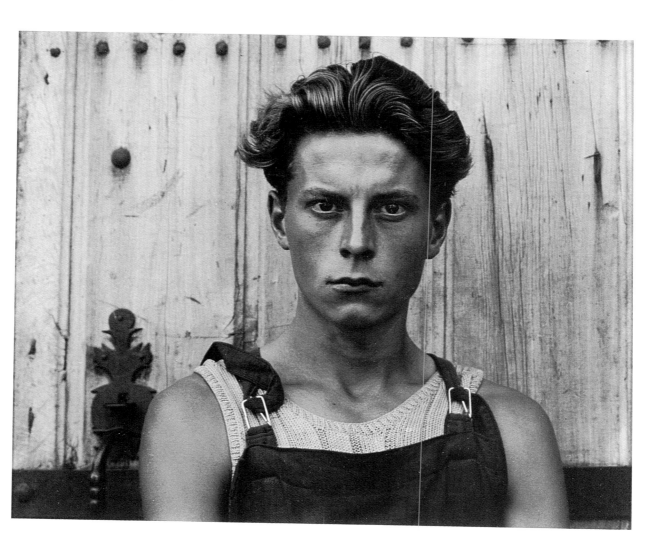

Strand, along with Alfred Stieglitz, Edward Steichen, and Clarence H. White, stands at the forefront of early 20th-century fine-art photography in America. Dedicated to photographic perfection, Strand used a large camera to precisely and analytically capture his subjects. His prints, rarely larger than 8 by 10 inches, are emotionally cool and still. This image is from *Profile of France*, one of Strand's books devoted to specific countries. Not travel books in any sense, they are poetic evocations of the distinctive character of each location and its people.

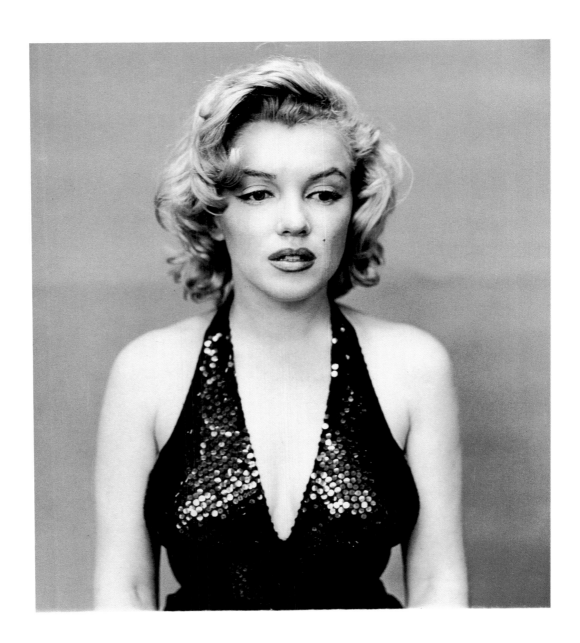

Richard Avedon

American, born 1923

Marilyn Monroe, Actress, 1957

Gelatin silver print

The Christina N. and Swan J. Turnblad

Memorial Fund

81.94.10

© 1957 Richard Avedon

Well known as the most widely published fashion photographer of all time, Richard Avedon, more importantly, is the greatest portrait photographer of our time. He is not a photojournalist or documentarian. Instead, he scrutinizes the personalities that epitomize, evoke, and shape America's cultural psyche. Avedon gives us an entirely subjective yet unflinching characterization of his subjects. Here Marilyn Monroe appears fragile, tentative, bewildered, and vulnerable, seemingly bemused and dazed by her fame and identity.

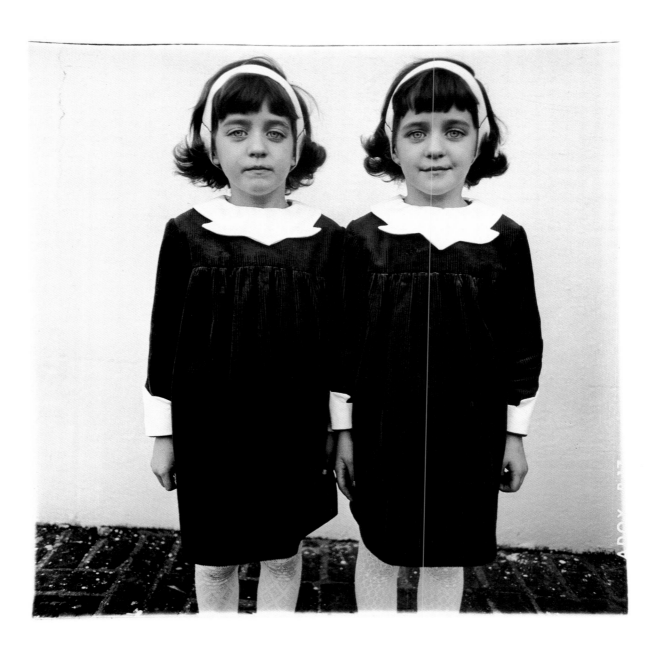

Diane Arbus began her career as a photographer in the 1940s. She supported herself by working for national magazines, which gave her access to all stratas of American society. The rich and famous of Hollywood posed for her. So did the poor and anonymous of the rural South. Arbus is probably best known for her often unnerving portraits of sideshow performers, transvestites, nudists, grand eccentrics, and normal middle class homes and their owners.

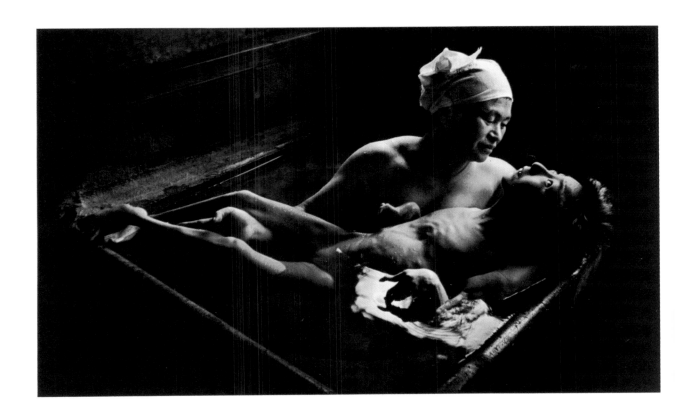

W. Eugene Smith

American, 1918–78

Tomoko and Her Mother Bathing, 1972

Gelatin silver print

The Alfred and Ingrid Lenz

Harrison Fund

94.14

© Aileen M. Smith

W. Eugene Smith is universally regarded as one of the 20th century's finest photo-journalists. He photographed for *Life* magazine during World War II in the Pacific, where he was seriously injured. After a two-year recovery, he continued his work for the magazine, creating photographic essays that established him as the preeminent American photographer of the 1940s and 1950s. In this picture, a mother bathes her child, who was tragically deformed by prenatal mercury poisoning.

aspiring young Swiss photographer in New York just after World War II,
ank was captivated by the drama and ironies of the city. He photographed in the
reets by day and night, creating intense and poignant images that evoke both
e gritty realities and the charm of New York. His book *The Americans*, first pub-
shed in Paris in 1958, was widely criticized for its negative tone. This image
ppeared on the book's cover and has since become a symbol of American photog-
phy of the period. Frank, an early recipient of a Guggenheim Foundation
llowship, was a protégé of Walker Evans and Edward Steichen, both of whom

ROBERT FRANK
AMERICAN,
BORN SWITZERLAND, 1924
Parade, Hoboken, New Jersey, about 1955
Gelatin silver print
The Robert C. Winton Fund
84.104

PRINTS AND DRAWINGS COLLECTION

Established in 1916 when trustee Herschel V. Jones donated a collection of 5,000 prints, the Department of Prints and Drawings at The Minneapolis Institute of Arts is responsible for the care, exhibition, and acquisition of works of art on paper, including woodcuts, engravings, etchings, lithographs, screenprints, drawings, watercolors, pastels, monotypes, multiples, artists' books, and rare books. Ranging from early 14th-century illuminated manuscripts to contemporary works on paper, the Institute's permanent collection of prints and drawings is encyclopedic in scope and comprehensive in graphic media.

Internationally recognized for its exceptional quality and depth, the collection today contains nearly 47,000 original works of art, including about 43,000 prints, 3,000 drawings, and 600 artists' books. Among the highlights are old master prints by Albrecht Dürer and Rembrandt van Rijn; a rare presentation copy of Francisco de Goya's *Los Caprichos*; 19th-century French and British prints and drawings; German Expressionist prints; the Minnich collection of botanical, zoological, fashion, and ornamental illustration from the 15th to the 20th century; 19th- and 20th-century artists' books; contemporary American and European prints and drawings; the Vermillion Editions Limited Archival Collection; and a wide array of works by Minnesota and regional artists. The collection has been enhanced over the years by the gifts of many generous donors, most notably John E. Andrus III, Richard Hillstrom, and the Prints and Drawings Council.

EDGAR DEGAS

FRENCH, 1843–1917

Beside the Sea, 1869

Pastel on tan wove paper

Gift of Ruth and Bruce Dayton

96.86

ANTONIO POLLAIUOLO

ITALIAN, ABOUT 1432–98

Battle of the Naked Men, about 1470

Engraving

Bequest of Herschel V. Jones

P.68.246

This work, the only known print by Pollaiuolo, a famous 15th-century Florentine goldsmith, painter, and sculptor, has long been admired because of the artist's masterful rendering of the human form. Relatively rare in any condition, this print is one of just forty-five impressions of the engraving in existence.

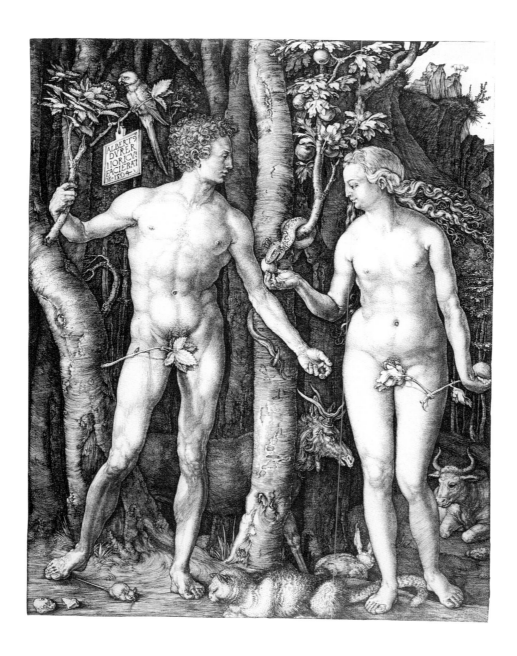

Long esteemed by collectors and art historians for its classical elegance and technical virtuosity, this engraving illustrates Dürer's theoretical study of human proportions. Although the subject of the print is clearly religious, Dürer's primary goal was to create perfectly formed nude figures. He enhanced the scene with numerous symbolic details to convey both the traditional biblical story and the medieval belief that related the Fall of Man to the four humors.

ALBRECHT DÜRER

GERMAN, 1471–1528

Adam and Eve, 1504

Engraving

The Christina N. and Swan J. Turnblad

Memorial Fund

P.12,613

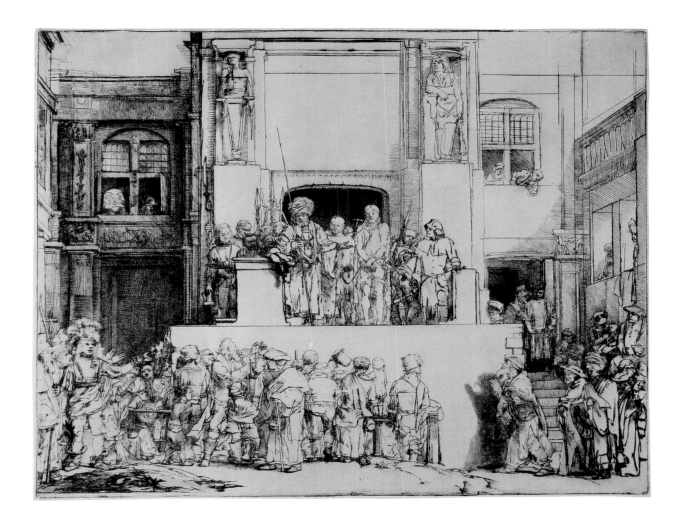

REMBRANDT VAN RIJN

DUTCH, 1606–69

Christ Presented to the People, 1655

Etching and drypoint

Bequest of Herschel V. Jones

P.68.408

Rembrandt executed this work primarily in the medium of drypoint, scratching his composition into the surface of a copper plate with a needle and throwing the metal displaced from the scratched line up on either side. This residue, called the "burr," creates lines with a dark, rich, velvety texture when the plate is inked and printed. However, the burr is fragile and quickly wears down with each subsequent printing. This brilliant impression of *Christ Presented to the People* is remarkable for the quality of its rich drypoint lines and its large scale.

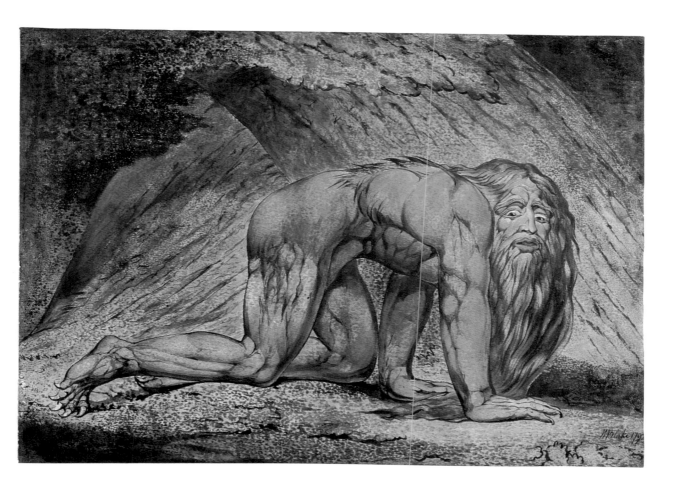

This rare color monotype shows the transformation of Nebuchadnezzar from man to beast. God punished this king of ancient Babylon for his destruction of Jerusalem and capture of the Jews by causing him to dwell "with the beasts of the field" and to "eat grass like an ox." Here, Blake depicts the moment when Nebuchadnezzar's "hair grew long as eagles' feathers, and his nails were like birds' claws" (Daniel 4:33). Blake produced these large color prints by first brushing the design on millboard and then taking an impression of the still-wet image. He later reworked the composition with watercolor and black ink to achieve the final result.

WILLIAM BLAKE
ENGLISH, 1757–1827
Nebuchadnezzar, 1795
Color monotype in tempera, touched with watercolor and black ink
Miscellaneous purchase funds
P.12,581

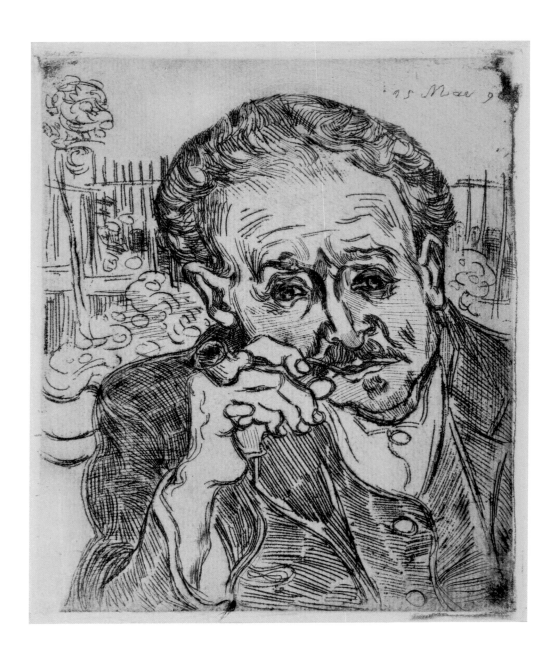

VINCENT VAN GOGH

DUTCH, 1853–90

Portrait of Dr. Gachet, 1890

Etching

The Bruce B. Dayton Fund

P.13,251

Vincent van Gogh first experimented with etching in Auvers, near Paris, during the last months of his life. He was guided by Dr. Paul-Ferdinand Gachet (1828–1909), an amateur painter and etcher who worked under the pseudonym van Ryssel. Gachet prepared the copper plate for van Gogh and assisted in the printing process. Van Gogh was enthusiastic about the possibility of reproducing a number of his paintings as etchings but never had the opportunity. He committed suicide about two months after making this etching. It stands as his only experiment with intaglio. Dr. Gachet was a friend and patron of many other artists, including Paul Cézanne, Camille Pissarro, Claude Monet, and Pierre-Auguste Renoir.

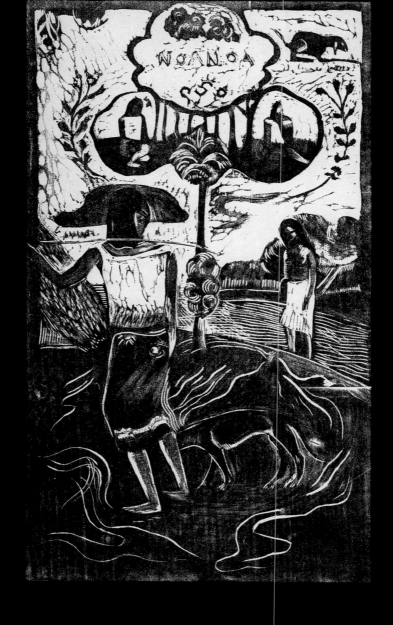

In 1893, Gauguin left Tahiti and returned to Paris, where his new paintings were misunderstood by critics and the public alike. After exhibiting his Tahitian works, Gauguin wrote *Noa-Noa* to explain them. He considered the woodblock prints in his book translations, rather than reproductions, of the paintings, sculptures, and drawings he had made in the South Pacific.

EUGÈNE DELACROIX

FRENCH, 1798–1863

Royal Tiger, 1829

Black chalk on white laid paper

Gift of Marion and John Andr

91.131.1

Animals were an important theme for Delacroix throughout his career. He was particularly fascinated with lions, tigers, and horses, animals that for him embodied the romantic concept of the irrational power of nature.

Delacroix created this black chalk rendering of a prone tiger as a preparatory study for his early lithographic masterpiece *Royal Tiger*, published in Paris in 1829. It is one of more than fifty known drawings and watercolors of tigers executed by the artist, many of which were drawn from life at the Jardin des Plantes in Paris.

In this screen, Pierre Bonnard brings the action of the street indoors. Bonnard
loved to portray the energy and spirit of babies, children, and dogs, which he
captures here by depicting a fashionable Parisian nanny minding her three charges.
The boys roll their hoops while the baby toddles in front of a stylish whippet.
Three nursemaids sit stoically in the background. Waiting horsecabs and stray dogs
fill the top of the screen.

In the first version of Promenade, Bonnard painted the panels with distemper, a
water-based wall paint; he adapted this to a five-color lithograph format two years
later. By creating a printed version, Bonnard made his original screen more afford-
able to a wider audience—prints could be purchased loose or mounted in the
screen. Bonnard admired and collected Japanese art, which influenced both his
choice of the screen format and his use of Japanese artistic principles.

The *Elles* (Them) series chronicles the private lives of prostitutes in the lavish Parisian brothels where Lautrec briefly lived in the early 1890s. With their permission, Lautrec observed and sketched the women as they went about their daily routines— entertaining clients, resting, grooming, washing, and dressing. He did not judge them but recorded what they have in common with other women.

HENRI DE TOULOUSE-LAUTREC
FRENCH, 1864–1901
Woman with a Tub, from the *Elles* series, 1896
Color lithograph, edition of 100
The William Hood Dunwoody Fund
P.75.43

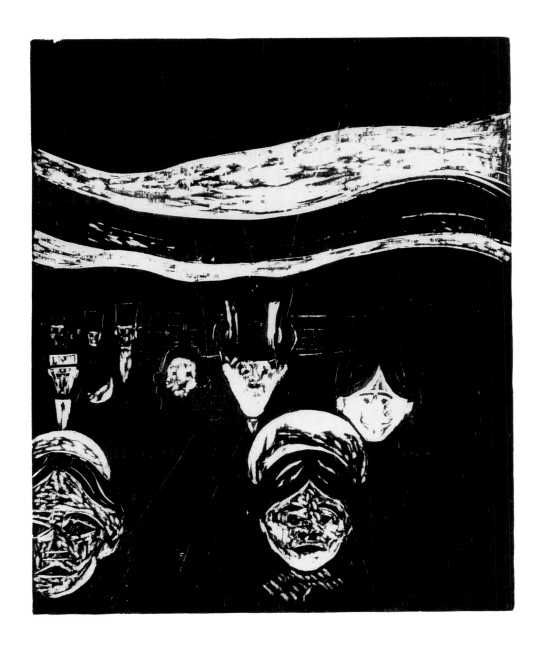

EDVARD MUNCH

NORWEGIAN, 1863–1944

Anxiety, 1896

Woodcut

Gift of Ruth and Bruce Dayton

P.13,396

Anxiety was Munch's first woodcut. He interpreted the theme in a lithograph earlier in 1896 but was attracted by the crudeness and simplicity inherent in the woodcut medium. Munch used a gouge, a knife, and a chisel to render the flat planes and abstraction in the composition.

Anxiety haunted the art and life of Munch. The ghostly figures that advance toward the viewer convey the loneliness and alienation of the artist. The setting is the Kristiani fjord, site of his painting and print *The Scream*.

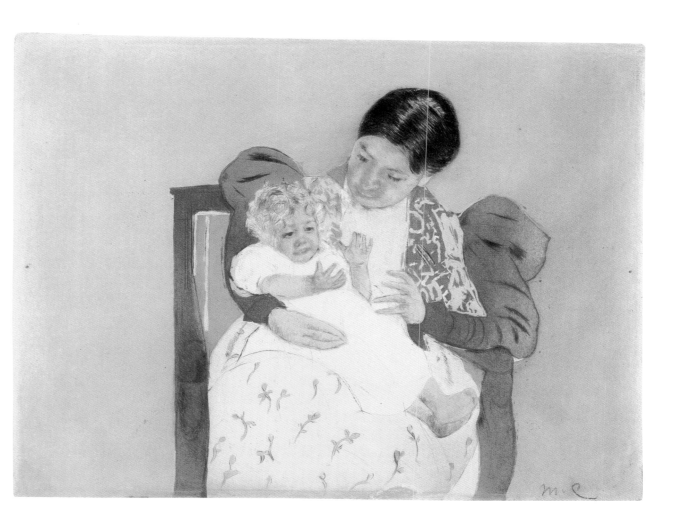

Mary Cassatt, an American printer who settled in Paris in 1874, exhibited with the French Impressionists during the 1880s. In this color etching, the flat, patterned areas and emphasis on outline clearly demonstrate her knowledge of Japanese woodblock printing. The intimate theme of mother and child typifies her mature work.

MARY CASSATT

AMERICAN, 1845–1926

The Barefooted Child, about 1896–97

Color drypoint and aquatint

Gift of Lillian and

Kenneth R. Smith

P.93.21.5

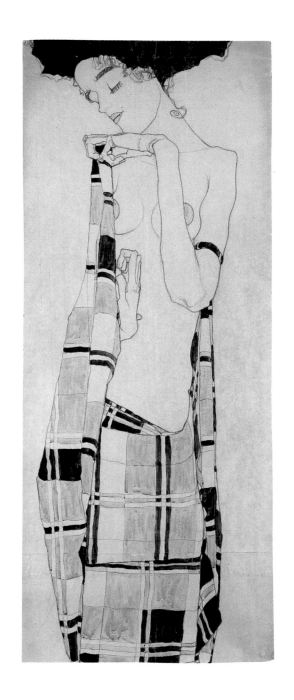

EGON SCHIELE
AUSTRIAN, 1890–1918
Gerti Schiele in a Plaid Garment,
around 1908–09
Charcoal and tempera on paper
Gift of Dr. Otto Kallir
and the John R. Van Derlip Fund
69.7

Schiele's drawing of his sister Gerti is a striking example of the eroticism that infused art in Vienna at the turn of the century. The work most likely was conceived as a study for a stained-glass window. Its provocative nudity and flat, decorative patterning can be linked to Viennese Art Nouveau and the work of Gustav Klimt, which influenced Schiele until 1909. The claw-like hands and emaciated body lend the teenaged Gerti an air of sinister decadence, reminiscent of popular depictions of the biblical temptresses Judith and Salomé. Although distinctly improper, which got Schiele in trouble with the law in subsequent years, this drawing shows the artist's confident mastery of line and his gift for portraiture.

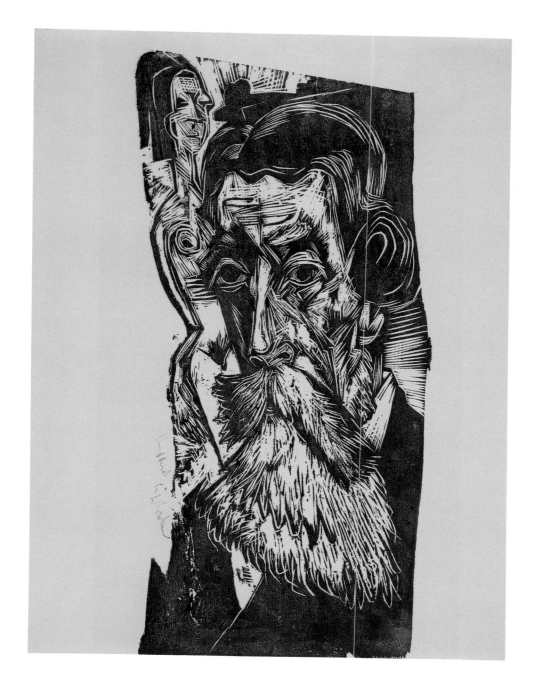

This woodcut of the art dealer Ludwig Schames is one of Kirchner's most powerful portraits. It was commissioned by the Frankfurt Art Association in 1918, a full year after Max Beckmann began exhibiting art in Schames's gallery. By this time, Kirchner was living in a small hut in the Swiss Alps, recuperating from his devastating experiences in World War I. Kirchner printed the whole edition of either 120 or 180 prints by hand because he did not have a printing press. He created the portrait from memory, elongating Schames's severe features to fit the irregularly shaped block of wood. The nude woman behind the art dealer is probably one of Kirchner's own wood sculptures. The vibrancy of the gouged marks and cross-hatchings, the uneven printing, and the unusual composition lend this portrait a sense of immediacy and expressiveness typical of the best of Kirchner's Expressionist works.

ERNST LUDWIG KIRCHNER
GERMAN, 1880–1938
Portrait of Ludwig Schames, 1918
Woodcut
The Ethel Morrison Van Derlip Fund
P.13,425

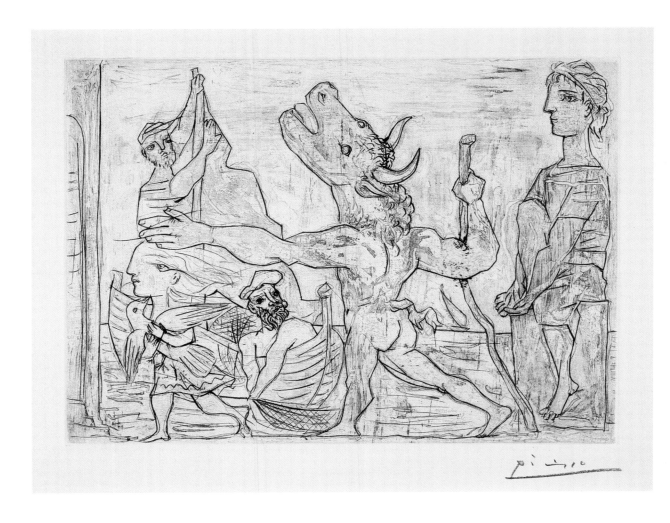

PABLO PICASSO
SPANISH, 1881–1973
Blind Minotaur Led by a Little Girl, 1934
Etching, engraving, and aquatint
Gift of Kenneth and Lillian Smith
P.93.21.17

This impression is one of a hundred intaglio prints Picasso executed between 1930 and 1937 for his dealer, Ambroise Vollard. The minotaur theme, which recurs throughout the series, was a metaphor for the artist. In 1927, Picasso met Marie-Thérèse Walter, who became his model and mistress for a decade while he was still married to Olga Kokova. Here, Picasso portrays himself as a blind minotaur being guided by Marie-Thérèse. His frustration over the entanglement with his wife and mistress is evident in the composition.

ed for twelve months in 1944, Henri Matisse created twenty

l wrote text in longhand for a book he called *Jazz*. Three

the book were reproduced in color *pochoir*, a French term

called the technique he used "drawing with scissors." He

HENRI MATIS

FRENCH, 186ç

Icarus from *Jazz*

Color pochoir

ANDY WARHOL

AMERICAN, 1928–87

Dollar Bill, 1962

This work comments on the idea that art is both a consumer item and a money-making venture for artists, dealers, and collectors alike. The image reminds us that artworks are often valued only for their monetary worth and are, for many, simply

ohns' paintings and prints, this work weds a flat, simple, standardized

nber two—to the subtle strokes and marks that reveal the hand of the

numbers in a context where they have no mathematical meaning,

JASPER JOHNS

AMERICAN, BORN 19

Figure 2, 1963

Graphite wash, charcoa

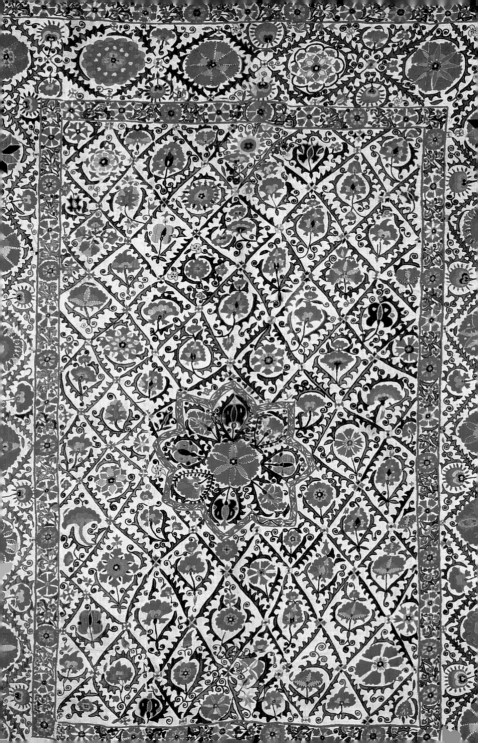

TEXTILES
COLLECTION

Like most important textile collections in American museums, the holdings at The Minneapolis Institute of Arts are encyclopedic in nature. Almost 5,000 items strong, the collection demonstrates the talents of European and Asian court artists as well as the pride and artistic identity of many ethnic groups. The objects represent diverse cultures, from ancient Rome and pre-Columbian Peru to 20th-century Bhutan and Morocco. They show the aesthetic preferences of urban artists and nomadic shamans and also tell stories of amazing technical achievement, from the intricate interlacing of basketry to the sophisticated machine weaving of complex fabrics.

Through lectures, publications, and special exhibitions, the collection has gained an international reputation for its spectacular individual pieces and its impressive holdings of European tapestries, early Italian laces, passementerie, Kashmir shawls, Turkish embroideries, urban and rural North African textiles, Bhutanese cloth, velvet and ikat fabrics, and 20th-century fiber art. Viewed individually or within an exhibition, textiles allow museum visitors to learn more about diversity of expression and the world's incredibly rich visual heritage.

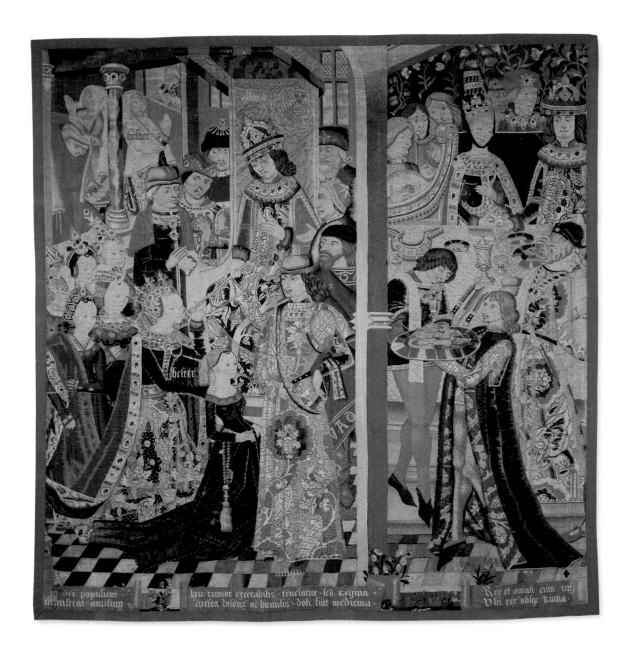

FLEMISH (PROBABLY TOURNAI)

Esther and Ahasuerus, about 1475–85

Wool and silk; tapestry weave

Gift of Mrs. C. J. Martin

for the Charles Jairus Martin

Memorial Collection

16.721

This tapestry probably belonged to a set depicting the Old Testament story of Esther. A beautiful young Jewish woman, Esther was the queen of King Ahasuerus (Xerxes) of Persia. When the king's chief advisor Haman (front, left of pillar) ordered all the Jews in Persia killed, Esther appealed to the king. At the left, Ahasuerus (on his throne) receives Esther (crowned and kneeling) and agrees to attend a banquet she has prepared. At the banquet (right), Esther asks Ahasuerus, who had not known she was Jewish, to spare her people. He grants her request, and Haman is later put to death. The feast of Purim, still celebrated today, commemorates this deliverance of the Jewish people. In typical medieval style, events occurring at different times are shown together. This tapestry is a fragment from the center of a larger piece that had at least three major scenes and several smaller ones.

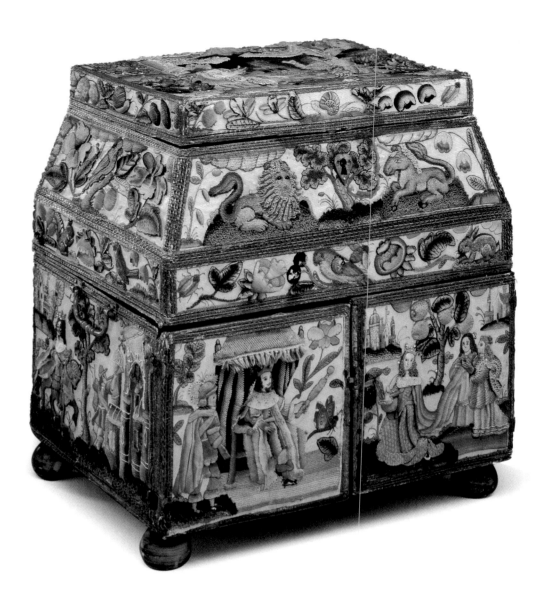

Needlework has always been an important art form in England. In the 17th century, a unique style of raised embroidery was very popular. In its most elaborate form, it was used to pictorially embellish decorative boxes for personal treasures. This piece, one of the finest of its kind, tells the Old Testament story of Queen Esther, whose intelligence and diplomacy saved her people from persecution.

ENGLISH
Stumpwork Box, 1662
Silk, metal, wood, and seed pearls;
embroidered
The John R. Van Derlip Fund
and gifts in honor
of Mary Ann Butterfield,
textile conservator at
The Minneapolis Institute of Arts,
on the occasion of her retirement
95.14

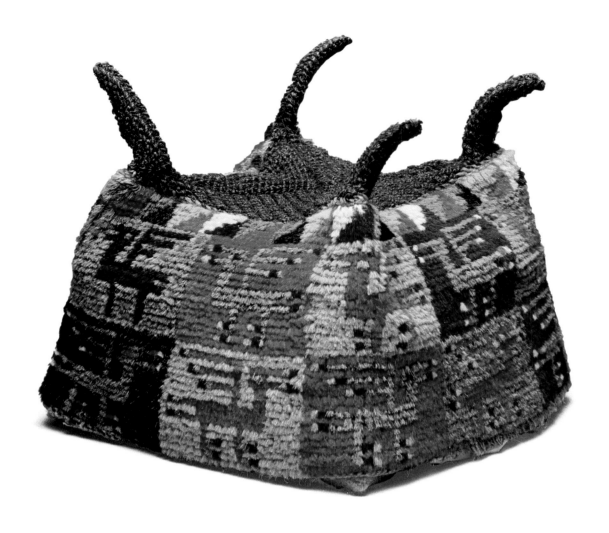

PERUVIAN, CENTRAL COAST
(HUARI)
Four-Cornered Hat, A.D. 500–800
Wool and cotton; loop interlacing
and knotting
Gift of funds from the Textile Council
98.32

A number of hats have been found among the archaeological remains of pre-Colombian civilizations. Among the most captivating are the pile-surface style from the Wari culture. According to several ceramic effigy vessels, the hats were worn rather high on the head. The extant examples, including this recent acquisition, are decorated with a checkerboard pattern incorporating animals, faces, and geometric motifs.

Like so many pre-Colombian textiles, this hat was made using an unusual technique invented by ancient Andean fiber artists. The looped threads are added during the construction process, which is consistent with the Andean emphasis on structural integrity and its balancing of two different motions at once. The loops are later cut to form the pile surface.

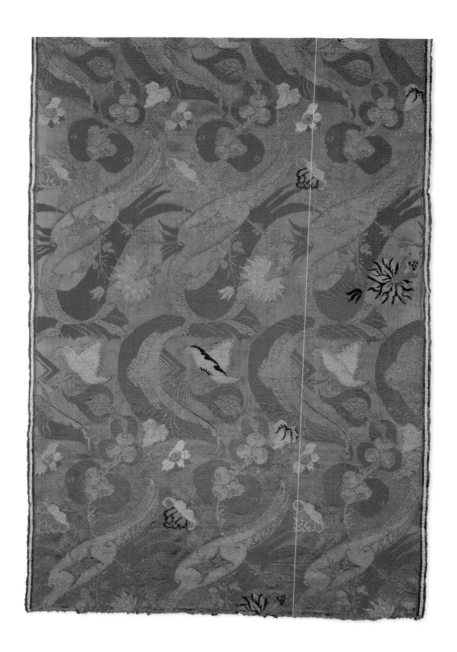

Large-scale, sinuous, fancifully patterned fabrics like this were developed in the last decade of the 17th century by Italian textile merchants who were losing their dominance in the luxury cloth trade to French production. Aimed at a wealthy clientele with a taste for exotic Indian and Far Eastern imports, these textiles often incorporated expensive materials, such as gold and silver threads, and large pattern repeats that were very labor intensive to manufacture. In an era when ostentatious displays of wealth were essential to social prestige, the fabrics were a success. Popular throughout Europe for almost twenty years, such cloth was used for everything from wall covering and upholstery to women's dresses and men's vests and jackets. Unfortunately for the Italians, the French quickly copied and adapted the new trend. They dominated the luxury textile trade for the next two hundred years.

FRENCH
Bizarre Silk Panel, about 1700–1705
Silk, gold, and silver; compound
woven structure
The Christina N. and Swan J. Turnblad
Memorial Fund
82.13.2

AMERICAN (BALTIMORE)

Quilt, second quarter of the
19th century

Cotton; appliquéd

Gift of Mr. Stanley H. Brackett in
memory of Lois Martin Brackett

75.9.2

Album quilts are a unique form of expression in quilting. Instead of one person making the entire quilt top, each square is created by a different individual. Church groups often made such quilts to honor ministers or class leaders. During the 1840s and early 1850s, the ladies of the Methodist Church in Baltimore were especially enthusiastic about album quilts. Sewing groups made many of them as gifts or to raise funds for church projects. On this particular piece, the top, cotton batting interlining, and backing have been closely quilted together with stitches that complement the appliqué pattern.

From the 17th through much of the 18th century, affluent Norwegian farm families gave tapestries like this bedcover as wedding gifts or included them in a trousseau or dowry. Biblical references often dominated the design. The wise and foolish virgins theme was the most popular subject, perhaps because it allowed the piece to teach an important moral principle.

Many household items were woven by the women of the family, but some objects like this, which required a particular weaving skill, were made by specialized

NORWEGIAN (GU
The Wise and Foolish V
second half of the
Wool; tapestry
The William Hooc
43.18

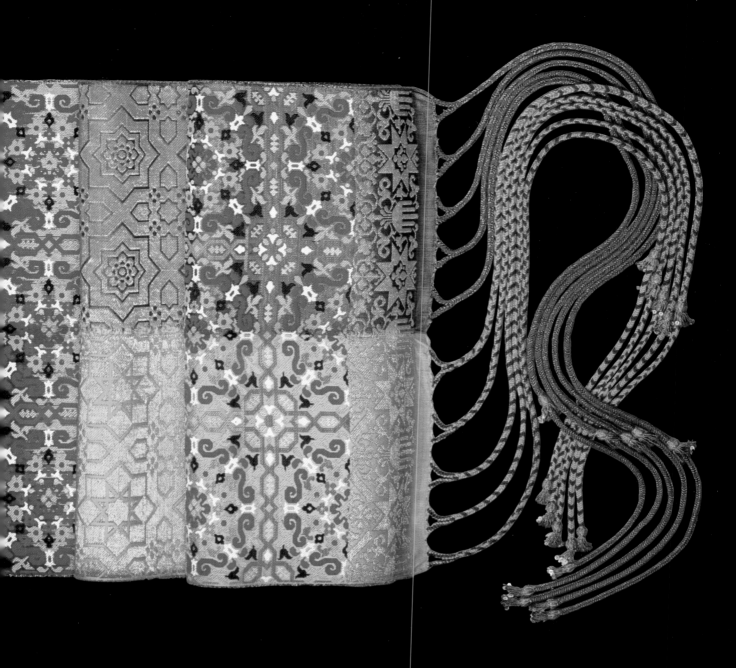

Weaving technology used by urban Arab weavers was very sophisticated. A belt such as this, with its complicated and diverse patterning, probably required at least five specialists: a dyer to create the four warp colors, three coordinated weavers (one handling the weft thread and ground structure and two developing the pattern), and a passementerie craftsperson to finish the braided warp ends and tassels.

Fine wool weaving was done throughout North Africa and generally used regionally, but urban silk weavers often produced specialized textiles for communities in quite diverse locations.

MOROCCAN

Wedding Belt, 20th century

Silk and metal threads; lampus weave

The Tess E. Armstrong Fund

and gift of Constance Kunin

and an anonymous donor

98.7.2

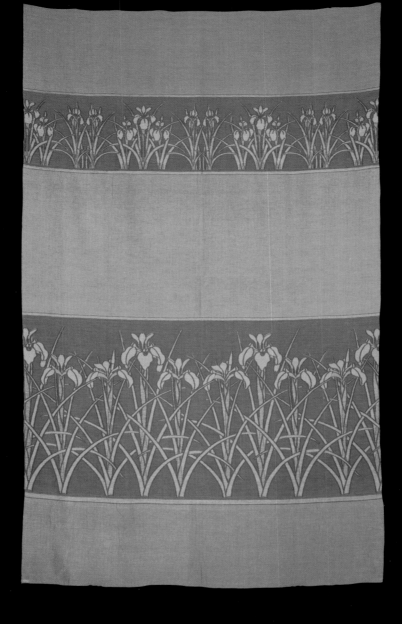

POSSIBLY ALEXANDER MORTON

SCOTTISH, 1844–1923

Curtain Panel, about 1900

Cotton; supplementary weft patterning

Gift of Mary Ann Butterfield and

Louis and Anne de Ocejo

95.20

In the 1890s and early 20th century, Alexander Morton worked as a weaver for Darvel in Scotland. He developed a supplementary weft patterning technique he called "Madras muslins" and produced several fabrics for William Morris and many leading designers of the day, including Voysey and Lindsay Butterfield. The coloring of this curtain was very popular on the continent at the time. Morton might have manufactured it for Liberty, one of his main clients, for their shop in Paris.

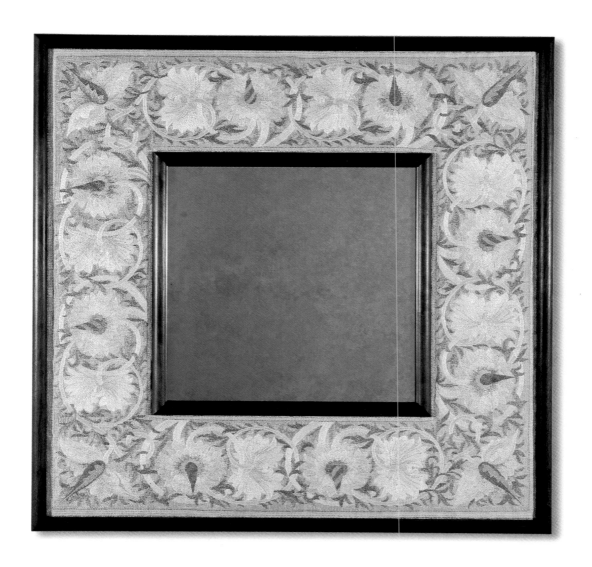

The English Arts and Crafts movement reasserted the worth of handmade objects in the face of 19th-century industrialization and mass production. William Morris (1834–96), considered the leader of the movement, founded Morris, Marshall, Faulkner and Company, which produced some of the finest decorative objects of the 19th century. Furniture, wallpaper, textiles, and stained glass created in his workshop lived up to the famous Morris credo: "Have nothing in your home that you do not know to be useful or believe to be beautiful." Morris described decoration as "an alliance with nature." Indeed, many of his textiles and wallpaper designs contain floral motifs. This surround, rendered with silk floss on a cotton background, features lilies and leaves entwined in a geometric pattern. The embroidered border framed with walnut wraps around a mirror.

ENGLISH

DESIGN ATTRIBUTED

TO MAY MORRIS, WILLIAM

MORRIS WORKSHOP

Mirror Surround, last quarter

of the 19th century

Embroidery, silk, and linen

The Christina N. and

Swan J. Turnblad Memorial Fund

89.110

I am interested in investigating...ways to create textiles which are not only aesthetically pleasing because of design and color, but also contain elements of tactile and visual surprise, pleasure, excitement.

Trained as a printmaker and sculptor, Claire Zeisler became interested in woven structures in the 1950s. She created sculpture from a variety of fibers—jute, sisal, raffia, silk, and wool—and in the mid-1970s began working with leather. Leather did not require weaving, knotting, or joining but could be cut and draped. This piece consists of a freestanding metal armature supporting hundreds of strips of cut leather that cascade in a shifting series of red and gray planes.

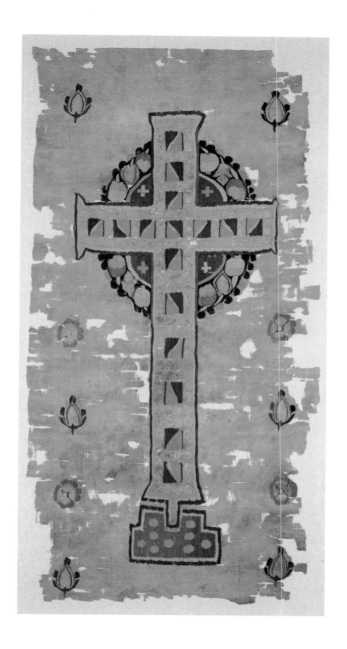

This cloth was made by a Christian weaver to be used as a sanctuary curtain in a Coptic church or possibly a monastery. It probably served later as a burial pall for an important person. Because Egypt's climate is conducive to textile preservation, the fabric was still in good condition when it was unearthed, probably in this century. Patches where the cloth had been mended can still be seen.

With its many symbolic images, including a large Latin cross, this curtain is among the most important early Christian fabrics that survive today. The combination of a wreath, which was traditionally awarded to winners of competitions, and the cross, which refers to Christ's crucifixion, was meant to remind the viewer of the Christian message of the joy of everlasting life.

EGYPTIAN (COPTIC)

Sanctuary Curtain, 5th–6th century

Linen and wool

The Centennial Fund

83.126

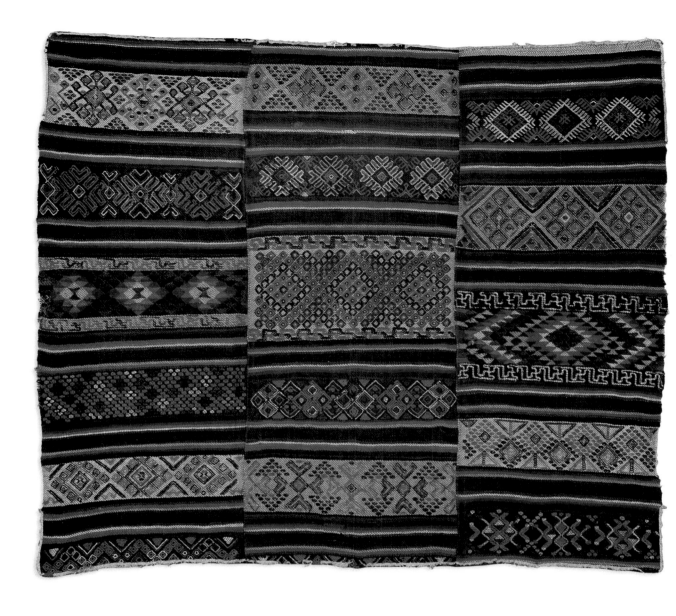

BHUTANESE

Woman's Dress (Kushüthara), 20th century

Silk and cotton;

supplementary weft patterning

Gift of N. Bud Grossman

82.102.1

This dress was most likely worn by a Bhutanese queen sometime between the two World Wars. The exceptional quality of the weaving, the use of expensive imported Chinese silk threads, and the elaborate, dense patterning are indications of the garment's importance. The royal family originally came from north central Bhutan, where this style of dress, which is wrapped around the body and held in place at the shoulders with two decorative pins, was particularly popular. It is now the official costume for women and required attire for public celebrations and religious festivals. Individual patterns have fanciful names, such as "monkey's nails," "flying wings," and "cooking pot lip." Weavers are encouraged to be bold and inventive with patterns and designs. This strong textile tradition is still vital. Even today the queen wears these stunning handwoven dresses.

Raffia cloth, a very labor-intensive textile to produce, was made by wealthy families who could afford to support women with exceptional weaving talent. The common people of the village dressed in beaten bark cloth. On ceremonial occasions, people wore their most expensive clothes and rarest jewels to show that they came from an old rich family—which accorded them respect within the community—rather than from new money.

IVORY COAST (DIDA)

Woman's Loincloth, 20th century

Palm raffia; oblique interlacing

and resist tie-dye

Gift of Nobuko Kajitani

97.67.9

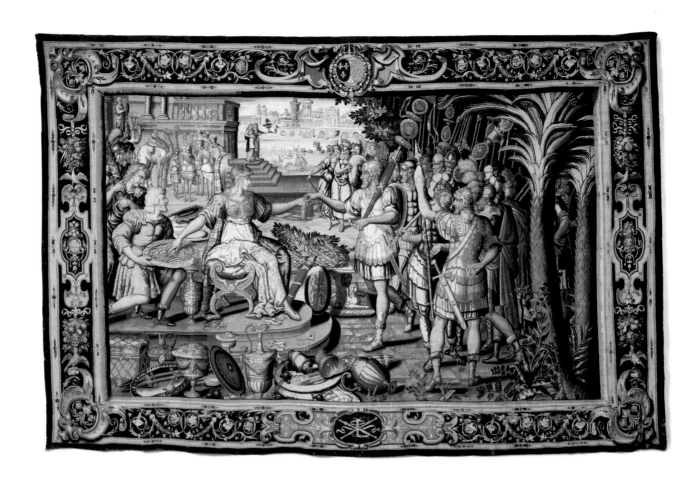

FRENCH

DESIGNED BY ANTOINE CARON

The Queen Distributing the Booty,

designed about 1562–65,

woven about 1611–27

Wool and silk; tapestry weave

Weaving attributed to the workshop of

Lucas Wandandalle at the Faubourg

Saint-Marcel manufactory of Marc de

Comans and François de la Planche

The Ethel Morrison Van Derlip Fund

48.13.10

This is one of a set of eight tapestries woven to tell the story of a widowed queen who needed to communicate to her subjects her qualifications to ably rule the kingdom until her son reached his majority. The original designs were created for Catherine de Médici, the widowed queen of Henri IV. They are the only known complete French royal set in the United States. Lest the widowed queen of France appear too direct in her attempt to sway public opinion, the story is told through the historic character Queen Artemisia, who ruled Caria (now part of western Turkey) in the second century B.C. This tapestry depicts the victorious Queen Artemisia paying her royal forces with jewels and gold plate after the battle of Rhodes, thus conveying the message that loyal subjects are richly rewarded.

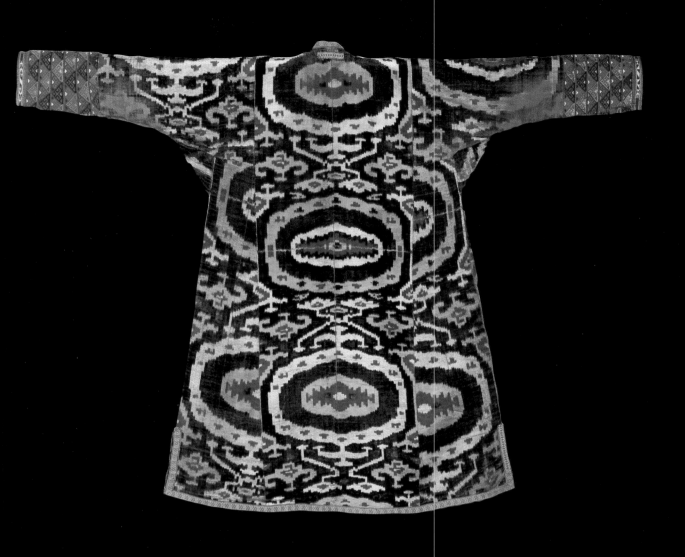

Ikat, a form of resist dyeing that creates a pattern on individual threads before they are woven, is demanding and very labor intensive. It has been practiced in various parts of the world, but during the 19th century in Central Asia it reached a high state of technical refinement and artistic boldness. Jewish dyers and Muslim weavers were particularly active in the production of this cloth. Most of the fabric, a combination of silk and cotton, was made into clothing. Velvet, the most expensive, indicated the wearer's wealth and status. Rich merchants and important tribal leaders on official court visits often wore velvet garments. Sometimes, as an expression of particular favor, the emir or an important court official would give an ikat coat as a diplomatic gift.

UZBEKISTAN
(PROBABLY BOKHARA REGION)
Coat (Bakmahl Chapan), 19th century
Silk and cotton, ikat; supplementary
warp patterning
The Ethel Morrison Van Derlip Fund
91.2

AMERICAN

Crazy Quilt, about 1905

Silk; pieced and embroidered

Gift of Eleanor Atwater,

Martha Atwater, Sandra Butler,

Ellie Donovan, Suzanne H. Hodder,

Anita Kunin, Laura Miles,

Eleanor W. Reid, and Kathleen Scott

This quilt was assembled in 1905 by Florence Barton Loring, wife of Charles Loring, father of the Minneapolis park system. The individual squares were made at the turn of the century by prominent members of society to honor their families or organizations.

The Berber women of the Middle Atlas region of Morocco have long been famous for their elaborate and dramatic weaving. Like cloth in many parts of the Islamic world, a mantel such as this is often multifunctional. When worn as a wraparound cloak, the fabric is held in place by a fibula, or pin, inserted through the overlapping corners under the chin. The cloth can also serve as a decorative bedcovering for an honored guest. Smaller textiles of this style are used to adorn animals taking part in weddings or other ceremonial celebrations.

Because these textiles are labor intensive and made from expensive materials, they often signify wealth. They also can demonstrate a personal aesthetic, ethnic identity through tribal-specific patterning and designs, or professional pride. Traditionally, a woman who was a skilled weaver was a most desirable bride.

MOROCCAN, MIDDLE ATLAS
MOUNTAINS (ZAIANE)
Woman's Mantel (Tamizart), 20th century
Wool, silk, and cotton threads
with glass beads and sequins;
weft faced with discontinuous
supplementary weft patterning
Gift of Donna and Cargill McMillan
93.25.1